# Photographer's
## Survival Manual

# Photographer's Survival Manual

## Survival Manual

### A Legal Guide for Artists in the Digital Age

Edward C. Greenberg, J.D. & Jack Reznicki

LARK
PHOTOGRAPHY
BOOKS

A Division of Sterling Publishing Co., Inc.
New York / London

Editor: Frank Gallaugher
Book Design: Tom Metcalf
Cover Design: Thom Gaines

Reznicki, Jack.
    Photographer's survival manual : a legal guide for artists in the digital age / Jack Reznicki & Ed Greenberg. -- 1st ed.
        p. cm.
    ISBN 978-1-60059-420-5
    1. Photography--Law and legislation--United States. 2. Copyright--Photographs--United States. 3. Artists' contracts--United States. I. Greenberg, Ed, 1953- II. Title.
    KF2042.P45R49 2010
    346.7304'82--dc22

                    2009048277

First Edition

Published by Lark Books, A Division of
Sterling Publishing Co., Inc.
387 Park Avenue South, New York, N.Y. 10016

Distributed in Canada by Sterling Publishing,
c/o Canadian Manda Group, 165 Dufferin Street
Toronto, Ontario, Canada M6K 3H6

Distributed in the United Kingdom by GMC Distribution Services,
Castle Place, 166 High Street, Lewes, East Sussex, England BN7 1XU

Distributed in Australia by Capricorn Link (Australia) Pty Ltd.,
P.O. Box 704, Windsor, NSW 2756 Australia

If you have questions or comments about this book, please contact:
Lark Books
67 Broadway
Asheville, NC 28801
(828) 253-0467

Manufactured in China

ISBN 13: 978-1-60059-420-5

For information about custom editions, special sales, premium and corporate purchases, please contact Sterling Special Sales Department at 800-805-5489 or specialsales@sterlingpub.com.

For information about desk and examination copies available to college and university professors, requests must be submitted to academic@larkbooks.com. Our complete policy can be found at www.larkbooks.com.

# 0 contents

# introduction

## THIS WAY OUT

You've been traveling in another dimension, another world. Not the world you chose—not the creative world of imaginative imaging, but a confusing land of legal mind twisters, myths, factoids, legends, and nonsense. You've been lost in the fog of The Copyright Zone: a place of contradictory facts, confusing opinions, half-truths, falsehoods, and fanciful tales that photographers and artists are prone to believe and share.

For example, do you believe that if you change someone else's photo minimally, slightly, or substantially, then you've created a new work and therefore have the right to copyright it? Do you believe that model releases are needed only by professional photographers using professional models, or that releases aren't needed in public places? Do you believe that you can use someone else's photo on your blog to illustrate a point or technique because such use is "fair use"? Do you believe that mailing a photo to yourself in a sealed envelope creates ownership or copyright of that photo?

If your reaction to any or all of the above is, "Sounds about right," then take this book and settle into a comfortable chair with a handful of differently colored highlighters and a stiff drink, because all of them are photographic equivalents of the alligators in the New York City sewers. They're myths.

Chances are you suspected as much. Maybe you picked up this book in the first place because much of what you hear about photo rights and copyright worries you. And maybe you suspect that self-proclaimed experts are leading you down the wrong path. Well, you're right. These days there's more incorrect information out there than you can imagine. Legends, factoids, myths, and "mythconceptions" abound in the photo industry; they spread among shooters like kudzu, and the Internet and e-mail send the process into overdrive.

We've often wondered why photographers are so inclined, even eager, to accept the expert opinions of other photographers. Maybe it's the commonality of experience. Perhaps we just want to trust people who are in the same creative game we are.

No matter the reason, we place an inordinate and often dangerous amount of reliance on the bad advice of other shooters. Copyright, photo use, and photo ownership are *legal* matters; close enough isn't good enough.

So you've come to the right place. The purpose of this book is to dispel the fog and lead you out of the copyright zone.

Who are we to say we can dispense the real deal of copyright law? We are Jack Reznicki and Ed Greenberg.

Jack is a world-renowned and respected commercial photographer based in New York City. Over his 30-year career, his blue chip clientele has included many Fortune 500 companies, major magazines, and large advertising agencies. He sat on the board of directors and is a past president of Professional Photographers of America (PPA). Twice, he's received the IPC (International Photographic Council) Leadership medal for "Excellence in Studio Photography" at the United Nations. Additionally, Jack is one of the original "Canon Explorers of Light," an "Epson Stylus Pro," and a Sandisk "Photo Master."

Ed has been practicing law in New York City for over thirty years, representing the top photographers and illustrators in the business (Richard Avedon, Mel Sokolsky, Chris Usher, MacDuff Everton, Michael Grecco, Anita Kunz, Marc Burkhardt, and—of course—the esteemed Jack Reznicki) as well as the average Joes and Janes striving to make a name for themselves. He has been on the faculty and a guest lecturer in the Masters Program in Digital Photography at The School of Visual Arts in New York, and lectured nationwide on photographers', artists', and models' rights on behalf of NAPP, PPA, APA, and EP. Ed regularly goes to court and tries real cases in front of real judges and juries, and has appeared before trial courts in several states in addition to arguing appellate cases at the State and Federal levels.

# How this Book Came into Being

Jack and Ed have been friends for over three decades. Over the years they've noticed a common trend in their respective areas of expertise: while most photographers excel in right-brain (creative) activities, there is a great deal lacking in left-brain (logical, business) thinking. Knowing each other for so long and sharing many frustrations, discussions, and business strategies over drinks, Jack and Ed decided to take their discussions on the road. Their audiences identified with their examples, horror stories, explanations, and practical solutions to the problems faced daily by creatives. Sometimes Jack and Ed are totally in sync when it comes to resolving problems. Often they approach the same issue from two different directions, and even—gasp—disagree.

With Jack leading the creative, right-brained side, and Ed presenting the logical, left-brained side, their tag team approach made delivering solid business information to creative people into an entertaining, fun experience—even though legal stuff is usually tedious and the last thing any artist wants to deal with. This book is an outgrowth of all those court cases, trials, discussions, lectures, questions, and a popular column in *Photoshop User* magazine written by Jack and Ed called "The Copyright Zone." Here they have the time and space to expand on the many issues they touch on but, because of live lecture time restraints, can't fully address.

Reading these pages is not a replacement for talking to a qualified lawyer if you need help. Let us repeat that: a qualified lawyer. An intellectual property lawyer, who knows copyright, and who knows the photography business. Not a lawyer who is a third cousin of your spouse, or your brother's neighbor's son who is a real estate lawyer. What this book will do short of a qualified lawyer is answer your questions and reveal the truth of copyright law.

What follows are illustrations of and solutions to real life problems faced by photographers in the digital age. Essential paperwork is included, and complex legal terms are deciphered. And scattered throughout are vignettes, case histories, and anecdotes that cover both the expected and unexpected hurdles faced by photographers every day. While many of these are humorous and sometimes light-hearted, make no mistake: between the covers of this book lies the information needed by photographers and artists looking to survive and thrive.

Jack Reznicki
Ed Greenberg

# Your Bundle of Rights

Although extremely valuable, copyright as a concept remains misunderstood, misused, misconstrued, and generally abused by photographers to this day. Their confusion seems to be the product of fear, and as Rod Serling's classic work on The Twilight Zone proposes, all fear comes from the unknown.

Knowledge, on the other hand, is not scary, and the only people who need to be frightened or intimidated by knowledge—in this case, your knowledge of copyright law—are those who seek to steal from you. So what is copyright? Simply put, it is a right that gives creators the control of their "original" work for a "limited" time. The copyright office states that the owner of copyright in a work has the exclusive right to make copies, to prepare derivative works, to sell or distribute copies, and to display the work publicly.

# Intellectual Properties

Copyright and intellectual property were once topics that put people to sleep. That changed when Bill Gates became the world's richest man and people realized that he built his wealth on the value of intellectual property—or rather, the value of selling the rights to that property, not even the property itself. Gates makes his billions by selling permission to use a product; it happens to be a computer operating system. He neither makes nor sells computers; what he does is license Microsoft's intellectual property: the Windows operating system. It's a nice line of work.

Unlike a camera, the purchase of which empowers you to use or dispose of it as you please, you don't own the Windows program you bought; you simply retain a license to use it. Nor do you own most music you buy; you own the right to listen to it. It's licensing that makes the owners of intellectual property very wealthy.

With that much money floating around, intellectual property and copyright issues mean big business. In fact, intellectual property law is one of the fastest growing specialties in law schools and law firms. Companies like Kodak, which lost most of the revenue once generated by film sales, now mine the wealth of their patents and copyrights to find processes and applications they can license.

But intellectual property concerns don't stop at large corporations; they've trickled down to small businesses and even to individuals. Ask any wedding photographer today how many brides want not only all the images of their weddings, but also all the rights to those images. That alone is a clear signal: you need a deeper, more comprehensive understanding of copyright—and not just laws and statutes. Knowing a bit about the history of intellectual property will give you a better perspective on what's happening today, how copyright is being interpreted, and how some people—lawmakers among them—see copyright laws as inhibiting intellectual freedom. If you Google the phrase "why copyright today threatens intellectual freedom," you'll get over 250,000 hits. That's right: Copyright protections are under attack.

This might surprise you, but copyright protection doesn't primarily exist to protect your rights as an artist. The Founding Fathers did not include copyright in Article 1, Section 8 of the Constitution to ensure that photographers—or any artists—could make a buck. Rather, they did it to "promote the progress of science and useful arts" and for a "limited time" allow you, the creator, to protect your work and profit from it. After that time has elapsed, your work is meant to improve the "commons of the mind," as Thomas Jefferson put it.

*Legal talk coming up. May make hair hurt in some individuals. Consult your physician after consuming and digesting.*

The right of derivatives is sometimes complicated. There are, in fact, several legal standards used by courts to determine derivative infringements:

The totality method, also known as the "total concept and feel" approach, takes the work as a whole with all elements included when determining if a substantial similarity exists. The individual elements of the alleged infringing work may by themselves be substantially different from their corresponding part in the copyrighted work, but nevertheless taken together be a clear misappropriation of copyrightable material.

The "audience" or "ordinary observer" test inquires whether an average lay observer would "recognize the alleged copy as having been appropriated from the copyrighted work." Some courts say this test should be conducted by comparing the two works with more attention to detail than a mere "generalized impression," but "still with no more attention than could be reasonably expected by a lay or ordinary observer." So it's a great start for the creator if an average, reasonable person has a spontaneous reaction when comparing the works and forms an impression that "copying" has taken place.

Finally, there's the two-part test. In determining substantial similarity, "The 'extrinsic' test considers whether two works share a similarity of ideas and expression based on external, objective criteria, "and the "intrinsic" test asks whether an "ordinary, reasonable observer would find a substantial similarity of expression of the shared idea."

# TITLE 17 OF THE U.S. CODE

This copyright law clarifies and lists additional rights you as a creator possess. These rights are often collectively termed "a bundle of rights." Here are the individual rights that collectively form your bundle:

**THE RIGHT OF REPRODUCTION:** You have the right to control how, when, and where your work is reproduced. You can specify and control this right through how you license your work.

**THE RIGHT OF DERIVATIVES:** This is a very important right, as it covers anything done with or to your work. If the work is altered in any way—say, retouched, cropped, or turned from color to black-and-white—then your original expression is protected. This right also means that if someone changes your image by a certain percentage, then they cannot claim the resulting photo as a new work that they are now free to own and use.

**THE RIGHT OF DISTRIBUTION:** You have a say as to how the work is distributed. If you don't want your work shown on TV, you can specify that. Don't want it on a cereal box or cigarette package? Don't want it displayed east of the Mississippi River or anywhere in Latvia? Say so, because you control the distribution.

**THE RIGHT OF PERFORMANCE:** This does not apply to visual art like photography, but rather to performance art like music, theatre, and dance.

**THE RIGHT OF DISPLAY:** This one is the visual artist's performance, and it means the right to control how the work is shown. For instance, you can say that your black-and-white image cannot be colorized. Or vice versa. You could state the work can't be cropped in any way.

And let's add another right, one that's not defined by the U.S. Code, but is real nonetheless and just as important as any of their stated rights: The Right to Say "No." As the copyright holder you have the right to say "No" to any potential user. You may refuse to permit anyone from using your image for any reason—or no reason at all. Make no mistake, the right to say "No" is a big hammer.

The US Code says "The owner of copyright in a work has the exclusive right." Exclusive means the copyright owner ONLY. "Only" is, by the way, a word you must add to your licensing vocabulary. For example: USAGE: 1/2 page in the *USA Today* issue of December 19, 2009 *only*." The word "only" is a way to exercise your right to say "No" without using that word. You can deny a license to anybody for any reason or no reason at all.

Your right to say "No" can also give you great leverage in negotiating when there is an infringement. Under certain circumstances, a federal court can issue an order preventing or flat out stopping an infringer or unlicensed user from using your work now and/or in the future. This is a very important remedy, especially if you are not entitled to statutory damages because you registered late.

For example, say an infringer has put your image on thousands of boxes of pain reliever in hundreds of stores like Wal-Mart, Target, and CVS worldwide. As the copyright owner, you have the ability to force a recall of all those boxes. This would cost the infringer millions of dollars, and they would have to reshoot and redesign the package for redistribution, all while their sales plummeted to zero. To avoid this fantastically expensive process, the infringer is often compelled to pay you for a "new license."

Lawyers and laymen who do not litigate copyright cases forget that this option may be available to an aggrieved creator; some inexperienced lawyers will turn down your case as soon as they hear that the work is not registered. There are those who view this gift of marvelous negotiating leverage as "commercial extortion." We, obviously, are not among them.

# warning

More legal talk coming up. When lawyers need to look up detailed explanations of copyright, they turn to the Copyright Act itself, to cases interpreting the law, and to definitive legal treatises on copyright law such as "Nimmer on Copyright." Lawyers do not rely on blogs or unverified information on the Internet—and neither should you.

## ON COPYRIGHT

There are three types of work that are entitled to copyright protection—creative, derivative, and compiled. Copyrights in these three distinct works are known as creative, derivative, and compilation copyrights (see below). Classically, an example of a creative work would be a novel. A screenplay based on that novel would be classified as a "derivative work" because it is based on a pre-existing work that has been recast, transformed, or adapted.

A compilation combines several works to create a new work, but it does not supplant the original copyrights. Any magazine, like *Time,* is a good example. They can hire a photographer to photograph a story and run it in the magazine. *Time* owns a copyright for that magazine as a whole, as published and pre-

sented. But they do not have any ownership of the individual photographs (unless they own the copyright). A compilation is not a derivative work.

Section 103(a) of the Copyright Act provides that the subject matter of copyright as specified by Section 102 includes derivative works. It reads in part:

"A work based upon one or more pre-existing works, such as a translation, fictionalization, motion picture version, art reproduction, abridgment, condensation, or any other form in which a work may be recast, transformed, or adapted. A work consisting of editorial revisions, annotations, elaborations, or other modifications which, as a whole, represent an original work of authorship, is a 'derivative work.'"

So in plain English, any work based in whole, or in substantial part, upon a preexisting (or "underlying") work, if it satisfies the requirements of originality, is separately copyrightable. So any "distinguishable variation" of a prior work is sufficient to support a copyright and is thus entitled to copyright protection.

A new version of a work (even in the public domain), abridgment, adaptation, arrangement, dramatization, or translation can constitute a derivative work. A collective work will qualify for copyright by reason of the original effort expended in the process of compilation, even if no new matter is added. In determining whether a work based upon a prior work is separately copyrightable as a derivative or collective work, the courts do not consider whether the "new" work is an improvement over the prior work. Quality is simply not an issue and not in the purview of the Copyright Office or copyright law.

However, in order to qualify for a separate copyright as a derivative or collective work, the additional matter injected in a prior work, or the manner of rearranging or otherwise transforming a prior work, must constitute more than a minimal contribution.

The following contributions to pre-existing works have been held to be too minimal to warrant the recognition of a new and separate copyright as a derivative or collective work:

* merely changing the form of a table of facts from a vertical to a horizontal orientation

* the selection of cities included in a public domain map

* a change in materials (metal to plastic)

* changing the scale or size of a work of sculpture depicting Uncle Sam (including certain minor changes in the shape of some features)

On the other hand, the following were held to be sufficient contributions so as to warrant the recognition of a separate derivative or collective copyright:

* devising a calculated melody score for a song already in the public domain—plus putting it in a form to be read

* adapting a public-domain embroidery design to a print fabric design

* the selection of scenes from a number of Charlie Chaplin films for incorporation into a compilation, in which originality was found in the selection of particular scenes, the order, timing, pacing, and theme

A derivative work is, by definition, bound to be very similar to the original. Concentrating the right to make derivative works in the owner of the original work prevents what might otherwise be an endless series of infringement suits, each more difficult to prove than the next.

## case studies

### What is the Public Domain?

When a work has no copyright protections, it is considered part of the public domain and, as such, can be freely used by anyone. It is the intellectual equivalent of public property, meant to be available to and enjoyed by everyone.

Most works fall into the public domain because their term of copyright protection (currently the life of the author plus 70 years) expires. Additionally, any and all works created by the U.S. Government are immediately entered into the public domain. All those pictures NASA takes of the galaxy? They're yours to enjoy and use as you please.

And finally, a work could pass into the public domain by default if copyright formalities weren't followed—like not including a copyright notice on your work if it was published before 1977.

## What is Copyrightable?

So that's your bundle of rights under the copyright law. They're yours unless and until you sell, transfer, or give away your copyright. Do that and you will lose all control over that image. Do that and, obviously, you're no longer the copyright owner of the image you created. You can't put that image in your portfolio or on your website as an example of your work without the written permission of whomever you've given, sold, or transferred the copyright to. That's why we strongly suggest you never sell, transfer, or give away your copyright—unless, of course, someone wants to pay you an obscene amount of money. And you should know that many successful photographers have, in fact, carefully licensed to clients all rights for an unlimited time, and charged them obscene amounts of money. All the while, they've maintained ownership of their copyright—the keyword here is "licensed."

Now that we've talked about what copyright means to you, the issue is, what can you copyright? Well, you can copyright any of your photographs as long as they're "original expressions." In other words, not every photo you take is copyrightable. You can't, for example, claim that you own the rights to a close-up photo of two hands shaking. According to our highly unscientific survey, since March of 1949, this rather popular stock image has been shot by 97% of all photographers who ever covered the concept of deal-making, successful business situations, political and social agreements, and approximately 14,238 other scenarios. Simply put, the image of two hands shaking is generic; it's not considered original and unless your expression of that image is unique or radically different from the thousands of others that exist, it simply will not be copyrightable.

But here's where you could get confused: The copyright office will take your money on a copyright registration submission of a work even if it is not an original expression. It will most likely issue a registration to you. But such a registration could be challenged and would likely not hold up in a lawsuit.

Another thing that copyright law doesn't protect is an idea. It can protect your particular artistic expression of that idea, but not the idea itself.

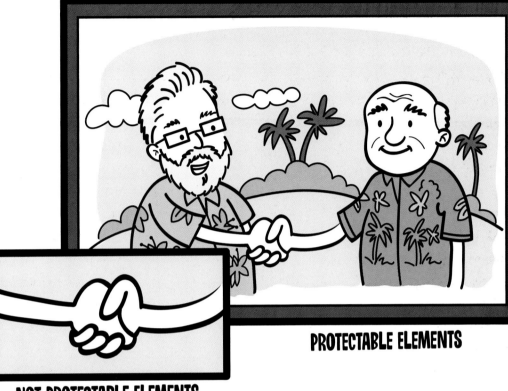

**PROTECTABLE ELEMENTS**

**NOT PROTECTABLE ELEMENTS**

Photographers can't claim ownership of an idea used to portray a subject or a situation. For instance, our friend Howard Schatz often photographs underwater nudes. That idea has been done many times, so while you can't take one of Howard's images, duplicate it exactly, and obtain a valid copyright, you can take the idea of nudes underwater and photograph your interpretation of that idea. Howard, while probably the master of this genre, cannot lay claim to ownership of the entire idea, nor any photo of any nude photographed underwater unless it's an exact copy of one of his photographs.

As another example, let's say you photograph a beautiful lighthouse at sunset; behind the lighthouse is a photogenic cloud formation. You can't claim infringement against anyone who photographs that same lighthouse at the same time with another beautiful cloud formation behind it. If that person copies your photo—the actual, physical photo—then you can sue for infringement. But you've got no case if he just photographed the same scene with the same idea in mind.

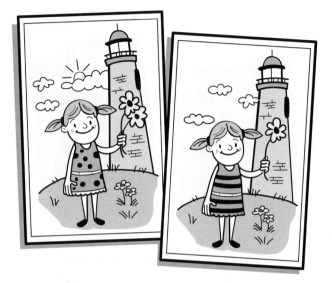

# PROTECTABLE ELEMENTS

Let's take it further. Say you photographed that lighthouse at a unique angle, used a blue filter, and had a little girl in a pretty dress standing there while holding two flowers. Along comes another photographer who shoots the lighthouse at the same angle, uses a green filter, has a little girl in a different dress in the scene, and she's holding just one flower. You now might have a successful claim for infringement; you can very possibly win. We can't say for sure you'll win—outcomes in court can never be guaranteed by anybody—but you would likely have a very good claim. Why? Because in the way you photographed the image there are certain "protectable elements" that are covered by your copyright. Protectable elements include posing, lighting, angle, background, perspective, shading, color, and viewpoint.

Not all elements are protectable. Photographer Penney Gentieu sued her stock agency, claiming infringement of her work because the agency sent out a request list for images that duplicated her imagery of shadowless babies photographed against a white background, which made them appear to be floating. Ms. Gentieu claimed that images produced by other photographers for the stock agency, per their request list, would be derivative works. The court ruled against her, saying that she could not lay claim to all images of babies against white backgrounds as an original expression. For her copyright to be infringed, those images would need to have been nearly exact duplicates of her images using protectable elements. Ordinary poses or angles that follow from the choice of subject matter—in this case, photos of babies—are not protectable, whereas contrived, unusual, or rarely seen positions might be considered actionable.

But with all that said, it always makes sense (within the guidelines of common sense—remember the two hands shaking) to take the position that all your images are unique. Maybe they are, and the prudent position is to register all of them. You can send a non-original image, one with elements that are not protectable, to the copyright office and they will likely take your money and issue a copyright registration complete with its

**THE KEY
POINTS HERE ARE TWO:**
First, always license your work;
never sell it. (Well, if you're look-
ing at a mountain of money
that will allow you to never
have to work again, then you
can sell it.)

**And second:** Register your pho-
tos. Always. And register them
all, whether or not you think
they're valuable. Let history—
and maybe a Federal judge—
decide their value.

star athlete might not be too valuable—unless it's on a cereal box. A photo of a guy sitting on a wall might not be valuable—until that guy marries a starlet and the gossip magazines want the photo. A photo of a little girl in school might not be worth much—until, tragically, she's murdered. The last two examples are from real cases, and we'll be talking about them in detail. For now, the point is: you never know how valuable a photo may someday be. So the answer to how much a photo is worth is: It depends.

# historical briefs 1600s, Part 2

COPIES WHILE YOU WAIT

## GUTENBERG'S PRINTING PRESS

Before technological advances in the 1600s, copy-right was not a great concern; there simply wasn't that much to copy. Bibles were pretty much it, and if you wanted your bible reproduced, then you went to your local St. Kinko's Monastery and asked the Abbot to make a copy. Of course, it would take a few years—longer if the monk died (and you thought running out of toner was a problem).

Then Gutenberg changed everything. His printing press expanded reading lists beyond Bibles to in-clude newspapers and (eventually) novels. In a very real sense, moveable type was responsible for the novels of Charles Dickens. Interestingly, the same people who today argue the merits of film versus digital were around back then taking part in the pen-versus-press debate.

# ORPHAN WORKS

Of course everyone should register their copyrights; but the fact that a photographer creates and owns their copyright the moment they trip the shutter, makes for some sticky situations. For instance, if you wanted to use a work whose creator was unreachable or even dead, you can't until you obtain proper permission. So assuming you were not the photographer at your parents' wedding and have a lovely wedding photo that you want to copy and blow up for their 50th anniversary, you are out of luck without getting written permission from the original photographer. Any copying of that photo might simply be illegal. Even if you know for a fact that the studio is no longer in business or the photographer was the victim of a high-profile murder that inspired its own episode of Law & Order, it still falls on your shoulders to acquire written permission. In the latter case, that would likely be from the estate of the photographer. If you run into a dead end, the work is "orphaned" and cannot be legally reproduced. This is also true if you have an old photo of yourself or a loved one and want to have it restored because of damage or fading due to age. The restorer cannot legally make a copy to work on.

This quandary has led Congress to consider an "Orphan Works" bill. It is an attempt to open this logjam of unusable images so that, say, a documentary filmmaker like director Ken Burns can employ important images that are otherwise prohibited from use (unless they've fallen into the public domain). The same issue is of great concern to museums and universities. As of this writing there is no Orphan Works law in effect. One version did pass the Senate in the 2008 session, with a great deal of support. It did not get to the House of Representatives that year, but most legal scholars are fairly certain some version will eventually get passed by both houses of Congress and will eventually become law.

Nevertheless, there has been much yelling, screaming, crying, and even some well-reasoned objections coming from the creative world against an Orphan Works bill. A lot of it is misinformation, wedded to hysteria, bouncing around and permeating the Internet. One photographer's website that dispenses legal advice tried to paint it as an invitation to infringe on copyrights. It posited that, if someone took an ad for a consumer company like Nike and cut off the bottom half inch that contained all the copy info and logo, then they could claim it as an orphan work and infringe the photo (steal it). That photographer—who is not a lawyer—used an example of a pet food ad done in Europe where all the copyright information was in the bottom half inch, and could easily be cut off. If the photographer found the infringement, the author reasoned, the infringer could claim they looked but couldn't find the photographer. They saw a similar image in stock for $100 and that would, in effect, be the limit of damages to the infringer's wallet. This scenario was not only patently wrong, but it invited Ed's involvement. Those of you who know that in our business, everyone knows practically everyone else will get a kick of this.

© Vincent Dixon

First, cutting out the logo did not make a work an orphan. If it ran as an ad, especially for a high-profile company like Nike, that image would never become an orphan work. Virtually impossible. The consumer ad and visible logo demonstrate that the infringer could not possibly have conducted a diligent search for ownership. All the versions of the bills that we've seen require that a provable, diligent search be conducted so an infringer can't hide behind an orphan status, and all applicable copyright laws remain in effect.

Second, the pet food ad (not a Nike ad as explained, because Nike would be down their throat in a second) that the website author used to illustrate his point was an ad shot by one of Ed's clients—Vincent Dixon. Vincent is a well-known photographer who does a lot of work in both the U.S. and Europe. Ed sent the website author a wonderful letter saying, in no uncertain terms, that their (ironic) use of ripping off a working photographer as an example of how nasty people could

easily rip off poor photographers, had to come down immediately. They complied and then tried to explain that the use of the image constituted "fair use" and was thus permissible. Another letter from Ed clearly explained why such a claim was, as the lawyers like to say, "utterly without foundation in law or fact." (English translation: nice try but we ain't that stupid. See our explanation of legitimate "fair use" on page 50.)

This is a great example why Ed and Jack are leery of non-lawyers with websites dispensing what masquerades as legal advice to photographers. It's like having Joe the Plumber giving out medical advice. And people actually listen because, hey, it's easily accessible on the Internet, and the author, just like the reader, is a photographer. When teaching persuasive speaking techniques, this phenomenon is called the "commonality of experience." In essence, it's why a photographer would feel more sympathy for a photo studio going up in flames than, say, a plumber would. Identifying, empathizing, or being simpatico with the writer does not make the writer an expert.

So what do we think of Orphan Works Law? Well, nothing at this writing, as nothing has passed and it's hard to comment on something that does not yet exist. (We readily admit that such obvious logic is dismissed out of hand by both of our wives

on a daily basis.) The Copyright Office is aware of the concerns of both sides of the issue. It is not in a position to advocate a lessening of copyright protection, but does see orphan works as a real problem that has to be dealt with. It has pointed this out via a presentation to Congress by Marybeth Peters, the Head Registrar at the copyright office.

To get a good read on exactly where the problem stems from and the solutions proposed by the Copyright Office, we recommend reading Ms. Peters' testimony to the House Judiciary subcommittee on March 13, 2008; you can find it at www.copyright.gov/docs/regstat031308.html. It is enlightening reading, and since she is in charge we believe her testimony is more credible than the musings of photographers contained in any blog. Quoting Ms. Peters directly from www.copyright.gov/orphan referencing some of the criticism against the proposed bills:

"Some critics believe that the legislation is unfair because it will deprive copyright owners of injunctive relief, statutory damages, and actual damages. I do not agree. First, all of these remedies will remain available (to the extent they apply in the first place) if the copyright owner exists and is findable. Second, the legislation will not limit injunctive relief, except in instances where the user has invested significant new authorship and, in

doing so, has relied in good faith on the absence of the owner. Third, statutory damages, which are available only when a work has been timely registered, will usually not apply at all because the overwhelming majority of orphan works are not registered by owners but languishing in institutions and private collections. Fourth, one of the basic tenets of the legislation is that the available remedy will be proportionate to the nature of the infringement. Reasonable compensation, a standard derived from a leading case on copyright damages, will usually be within the range an owner could expect to recover in an ordinary infringement suit. And it should certainly reflect a reasonable license fee."

We believe that eventually some type of bill will emerge and when it does we will both have something to say about it. Neither of us believes that any such bill will spell the end of the world for creatives. As it stands now, if you do not register your work, with or without an Orphan Works law in place, you are severely restricted in your options to get satisfaction (i.e. money, attorneys fees, and injunctions) in the event of infringement. The most important lesson still stands: register your work, no matter what.

Orphan works are not a problem confined to America. It is a global issue. All countries that are Berne Convention signatories (see page 84) have or will have something to say on the issue. Canada passed an Orphan Works bill several years ago, and while Canadian copyright laws differ from U.S. laws, infringement anarchy (as predicted by some in the U.S.), has not come to pass. This does not mean, however, that we cannot as our good friends in South Park, Colorado say, "Blame Canada!" We just can't blame it in this instance.

# Have You Registered?

**THE SCENE:** 1800s, somewhere in the Old West. Our hero is standing tall, wearing white—white jeans, white chaps, white shirt, and of course, a white 10-gallon hat. It's a windy day on Main Street; nothing but tumbleweeds playing across the road. The windows of the wooden buildings have curtains moving slightly, as cautious townsfolk peer out into the scene. At the other end of the street, there stands Black Bart: the meanest, orneriest copyright bandit west of the Pecos. Dressed in black leather, with a handlebar mustache and an evil curl on his lip, Bart sneers at our hero.

The sun is high in the sky, and the air hangs heavy. Our hero reaches for his gun, takes a bead, pulls the trigger and...nothing. Nada. Just a loud click. Unloaded gun—whoops! The villain in black laughs, spins on his heels, and strolls out of town with the loot, yelling "Maybe next time, sucker!"

Now lets re-shoot the scene. This time there are bullets in the gun, and Black Bart knows it. As soon as our hero makes a move for his weapon, the villain's hat blows away, his mustache falls off, and his lip quivers with fear. He turns the loot over to our hero and walks away in chains. Justice is served.

Copyright without registration is a gun without bullets. The gun might look flashy and feel reassuring, but it's useless against a real thief. Since relatively few photographers register their work—perhaps only 5%, and that's being optimistic—odds are that you are not currently registering any or many of your photographs. If you are among the five percent, then you've protected your work. You have image insurance, just as you have camera or business insurance.

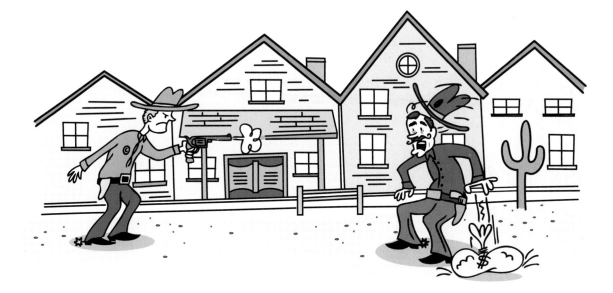

## WRITTEN BENEFITS

When you register your work, protections and remedies are available to you under the law, in addition to the copyright bundle of rights explained in Chapter 1. With registration, you have a very big shield that protects your work, and a very big club with which to pursue infringers. The additional rights you get by registering your work are as follows:

*THE ABILITY TO FILE A LAWSUIT:* That's right, you cannot file a copyright infringement suit against anyone without a registration in hand. Registration is your "key to the courthouse." Copyright is a federal law and copyright cases must be heard in federal courts. You can file in state court, civil court, or any other legitimate court of law, but (unless you count Judge Judy as legit) any court other than a federal court cannot hear a copyright suit and will kick it out the door. Of course, the court clerks in those other courts will take your money for the filing, only to then inform you that they can't hear your suit.

**COMPENSATORY DAMAGES:** To dissect the word "compensatory" in its root, it's the actual compensation for your work. This is essentially the value of the fees you would have earned had the infringer initially come to you in good faith and legitimately paid for a license of your image. The minimum compensatory damage would be the amount you would have charged had the infringer asked and fairly negotiated for use of the image with you. There are various factors in computing compensatory damages, but suffice it to say they are computed so as to award you (at least) the amount of money you have been deprived of by the theft of your image.

**STATUTORY DAMAGES:** In an infringement case, you can decide to collect either compensatory or statutory damages—but not both. Timely registration gives the copyright holder's lawyer the option to select which form of damages to seek out. Statutory damages are based on the court's discretion, and may be substantially higher than compensatory damages in some (probably most) cases. However, in other cases, especially when dealing with "big name" photographers and/or huge ad campaigns, the opposite may be true. There is a complicated selection process which takes place, and an attorney can even make the final call after the jury has determined the compensatory award. Bottom line—you are permitted to choose which form of damages will give you the most money.

**LAWYER FEES:** You gotta love this one. On top of the above damages, the court has the option of directing the losing party to pay for the prevailing party's lawyer fees and expenses. The court will accept itemized invoices,

## Judge Judy and why you should avoid arbitration and mediation

Arbitration and mediation services—including Judge Judy and all the other TV courts that are, in fact, binding arbitration sessions—are routes you can take other than a federal lawsuit; but they should be avoided. If you do go the arbitration or mediation route, and the case is decided in your favor, you will collect only actual damages, and likely not any statutory or punitive damages. Also, an arbitration might be heard by a judge who does not have the background or understanding of copyright and intellectual property laws. As a copyright owner bringing suit, that's not a great scenario for you; it places you at a huge disadvantage. You are much better off in front of an informed judge. Not to mention that arbitration and mediation are many times a paid service that can end up costing you a lot more money than a real court case would. It is really in your best interest to avoid arbitration and mediation and try to be heard in a federal courtroom.

paid bills, and similar backup material along with testimony from the winning attorney. If the defendant has been unreasonable in failing to settle the case or has otherwise wasted the court's time, such fee awards, while they must be "reasonable," may be quite generous. When they do award your lawyer fees, it's like hitting triple cherries on a slot machine. It feels right, and it feels good.

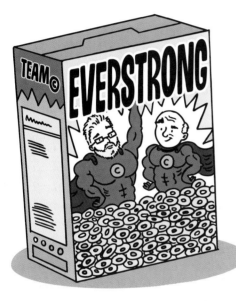

**INJUNCTION:** This is an order from the court directing that the photos at issue cannot be used by the defendant in certain media or used at all. Such an order may also take the form of directing and forcing the client to remove the advertising or product "from the stream of commerce" so long as the infringing continues. An injunction may also direct the removal of the image from the items on which it appears, as in "Pull those photo mugs off the shelves!" Injunctions may be temporary or permanent.

The threat and/or cost of having an injunction issued against an advertiser or client is intimidating and very convincing in pressuring them to offer a settlement. So if your image appears on an Everstrong cereal box and it ends up

## Common reactions from photographers regarding registering images at the Copyright Office go something like this:

"I don't shoot no stinkin' celebrities," "I don't hang with rock stars," "I don't have a big city studio," "I don't shoot fancy-schmantzy photos;" "I do shoot local people, everyday people, doing every day things, in everyday places," "I shoot for schools," "I shoot weddings, Little League, and VFW events." "So why do I have to bother with this legal stuff?" "Why should I spend time and money registering my images?" "I don't want to be a lawyer, I don't want to talk to a lawyer. My brother-in-law is a lawyer and he's a moron!"

Needless to say, none of the above are reasonable objections to registering your images. No matter the subject, and no matter your personal feelings about lawyers, it's always a smart move to register. As you'll see throughout this chapter, you never know which photos will suddenly become valuable.

on all the Acme Supermarkets' shelves, think of what it means if an injunction forces a client to remove the gazillion boxes that are out there. Think of the cost of destroying all those boxes. Think of the leverage and the size of the stick this gives you in talking with the infringer about settling your case.

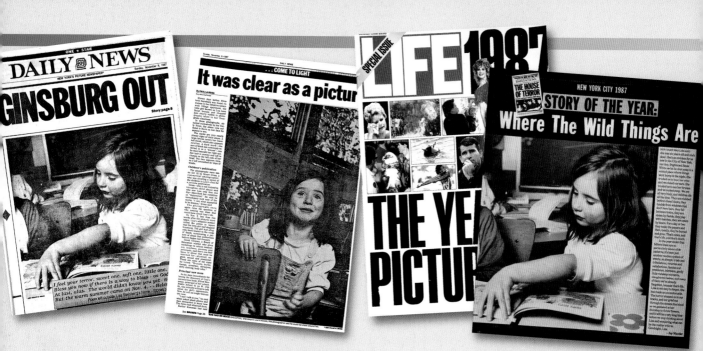

## LISA STEINBERG

In October of 1987, photographer Stuart Gross was on location in a New York City elementary school shooting a catalogue for his client, Scholastic Books. Stuart had obtained model releases for all of the children on the slight chance that one or more of the kids might be used in a shot.

He came upon a young girl who looked, well, sort of out of place. Unlike the other kids in her class, her hair was matted and her fingernails were dirty. Most importantly, Stuart noticed a "mouse" under the child's eye. He and his client questioned the young girl as to how she received the bruise. She was evasive. The child's teacher advised that Lisa received the bruise while fighting with her six-month-old brother.

With no intention whatsoever of using the child's bruised face and disheveled appearance, Stuart took several shots of her anyway. He was captivated by Lisa and photographed her on pure instinct.

A few days later on November 2, 1987, officers of the New York Police Department responded to an emergency call and found the young Lisa Steinberg comatose in the upscale, Fifth Avenue brownstone apartment of her adoptive parents. In addition to traumatic injuries that proved fatal, Lisa sustained other, less-severe injuries. Lisa Steinberg was ultimately taken off life support and her adoptive parents Joel Steinberg and his paramour, Hedda Nussbaum, were arrested in connection with her death.

The story immediately became public and was reported by virtually every local and national television network, newspaper chain, and news magazine in the country. It was even covered by the foreign press, publications in Europe, and elsewhere. There was an instant and significant demand within the print and television news industry for photographic images of Lisa Steinberg as she appeared at or before the time of her death.

Precious few images of Lisa Steinberg were known to exist at the time of her death and only one old, unrevealing shot became available for licensing purposes through *Newsday*. Until she became a murdered child, Lisa was not a public figure, and her adoption by Mr. Steinberg (a lawyer) and Ms. Nussbaum (an author of children's books) later proved to be illegal.

The photographs shot by Stuart demonstrated and portrayed evidence of systematic child abuse inflicted over a long period of time. Stuart called us as soon as the story broke, and we went to the New York County District Attorneys Office with the critical evidence. Along with Stuart's testimony, his photos helped serve as the basis for indicting Mr. Steinberg. The images created by Stuart Gross were—at the time of the assault and still to this day—the only photographs ever existing or published which demonstrate that Lisa suffered physical abuse, was a victim of such abuse prior to the fatal assault, and that she carried her bruises "in the open" for others to see. Later, Stuart became a star witness for the prosecution at the trial of Joel Steinberg. The District Attorney used the images as evidence and a fine relationship was developed between photographer and prosecutor.

From the time of the high profile murder, there was an immediate and frenzied demand from the print and television media for use and/or purchase of images of Lisa.. Stuart agreed to selectively—very selectively—license the images to specified media outlets that, he believed, would preserve the dignity of both the image and subject. In the days following the fatal assault, restrictive licenses were given to (only) the *New York Daily News* (front page), ABC Television, *Nightline, 20/20,* and WABC. Stuart rejected numerous proposals made by media companies to license and/or sell these images. Plus, the licensing agreements that he did grant specifically set forth how the images could be printed and used. Monies were donated to a charity dealing with abused children in New York City. Turning down substantial sums of money, Stuart made the conscience decision not to exploit the images in certain media or for certain purposes.

Over the span of the ensuing twenty years, Stuart extended licenses for the use of the images very selectively, including *Life* magazine's "The Year in Pictures 1987," where it ran as a two-page spread. Lisa Steinberg became the poster child for the formerly closeted issue of middle-class child abuse.

Infringements of the registered shots occurred many times over the next two decades. Unauthorized media outlets sought to use the images on numerous occasions, including, but not limited to: the time of the arrests, during the trial, at the sentencing of Joel Steinberg, at the plea deal for Hedda Nussbaum, upon Steinberg's release from prison some 18 years later, and requests continue today even after Stuart's untimely death. There are no equivalent or similar images of Lisa Steinberg out there and there never will be.

Most offenders knowingly infringed and elected to run the risk of being sued. Stuart and Ed prosecuted each and every violation.

Google the above phrase or any of its permutations, e.g. "You'll never shoot another job," "Now no one will ever hire you," and so on and you will get thousands of hits. The cliché, in one form or another, manifests itself when a creator, whose work has been infringed upon or whose bills have not been paid, has the temerity to express the intent to hire a lawyer. The threat of losing a non-paying client (especially in this economy) has been an effective deterrent when used on creatives. Yes, it is counterintuitive. Yes, it is illogical. And yes, clients know that it often works to prevent claims or lawsuits.

Some lawyers for media companies and publishers use the very same threat when speaking to us. They are spoon fed the phrase by their clients who have over the years effectively employed it against photographers and illustrators. Typically, it is used to scare creatives from pursuing monies due or prosecuting their legal rights under the Copyright Law.

Essentially, creatives are told that suing or even aggressively pursuing that to which they are entitled will blacklist them. If such were indeed the case, most of our clients would have long since closed up shop. We have never seen any evidence of a creative who successfully pursued a valid claim being blacklisted by any legitimate business. If any potential client is in fact deterred from retaining your services for such a reason, consider yourself lucky for having failed to make their acquaintance.

Anyone who threatens you because you seek what is yours by "putting the word out," disparaging or defaming you within the industry, or similarly threatening your livelihood, is exposing themselves to a potentially large civil law suit and in some cases, criminal charges.

Do you think that contractors, car mechanics, or ad agencies, if told by a deadbeat client that if sued, their services won't be used again, would curl up into the fetal position? Photographers, illustrators, artists, and graphic designers are, however, non-confrontational by nature. They scare easily and their clients know it. Some real life examples:

A. Model sues for unauthorized use of his/her image by consumer company. Model wins at trial. Model has been hired by the same company on one-half dozen occasions in the post litigation years.

B. Photographer keeps asking for return of his analog images shot on assignment (perfect for stock). Client stalls for months. Photographer (a really understanding, sweet guy) gives client a year to find pictures. Finally, client admits under modest pressure that the pictures from the shoot are lost. Photographer asks, "Why didn't you just tell me a year ago and make things right?"

"Whaddaya gonna do, sue me!?" client replies sarcastically. Photographer does, and is awarded about $160,000 by the court. Most compelling testimony? Client accurately re-counting the aforementioned "dare" in open court to an appalled judge.

C. Models complain to their modeling agency that advertisers have paid modeling agency but modeling agency has not paid models. Models told by bookers that complaining will assure that they will not be sent out for auditions or other-wise get work. Models stop complaining. Model agency closes up in the middle of the night after spending models' money.

D. Same as "C" above—just substitute the words "photographer" and "agent" for those of "model" and "modeling agency."

Whether and to what extent you assert your legal rights ought to be dictated by the veracity of your claims and the economics of pursuing them. Such decisions should be made in consultation with your accountant, your spouse, and your lawyer. Threats that suing will prevent you from working are akin to those threats made to us in our youth that our transgressions "will go on our permanent record."

# UNWRITTEN BENEFITS

These remedies and protections, standing alone or together with others, form a very, very big bludgeon when you tell a client or an infringer that your work is not just copyrighted but is also registered. If you find your work infringed and it's not registered, most likely the best you can hope for is to get them to stop using your work. But if your work is infringed and it's registered, cha-ching—you know money will be coming your way.

Along with these specific benefits of registration, there are also numerous "unwritten" benefits. One example of an unwritten benefit is that registration serves as real leverage to insure you will be paid after shooting a job and delivering an image or images to a client. It serves as a very big stick when your client is using your image and you still haven't been paid. If all you stand behind in such a situation is your unregistered copyright, a client can tell you to take a hike; sadly, you will find out that you likely don't have many other options. But with your copyright and registration, you have the upper hand. The threat of a lawsuit for copyright infringement is not like lawsuits commonly termed "theft of service" or a suit for "services rendered." Receipt of a complaint against an infringer with the stamp of a federal court for alleging copyright infringement is a very sobering experience. It's a serious and expensive matter regardless of the size of the infringing business or the finances of the defendant. And that's what gives you the upper hand with infringing clients, or clients who simply avoid paying you.

Nowhere does it state that a federal copyright lawsuit is an intimidating factor in settling or forcing payment, but let us tell you: It definitely is extremely intimidating. Many infringers are brazen and pugnacious until their attorneys inform them of what a federal lawsuit entails, the size of the lawyer's retainer, and what it may cost them if they're found liable of infringement. The prospect of a federal suit will generally deflate the blustering airbags, and settlements are usually made, saving both the client and you the expense of going to court. A federal copyright suit cannot be ducked or ignored. As sometimes stated, it's now a federal case.

## Definition of "Published"

Published means "presented to the public" and not just printed in a magazine or book. Displaying a photo on a website so anyone can see it is publishing; putting it on your website with password protection is not publishing, as the photo is not presented to the public. The same principle applies to a bride's wedding album. When you give the bride her wedding album, that's publishing, as you have no control over who sees it. But if you give a bride a book of proofs, that's not publishing as the images are considered work in progress.

One famous photographer never sends out any photographs without a specific license attached—including snapshots sent to his mother! This protects him from accusations that the work was previously published. If you send a photo out without any control (a license for instance) then it can be sometimes considered published. Even if it's far fetched, it opens a door for a lawyer to pursue. Better to have that door closed by registering the work before it leaves your hands.

## SO, HOW DO YOU REGISTER?

Registration is so simple that it takes longer to describe than to actually do. Still, you shouldn't try to register all the images you've ever taken at one time. Chances are you'll get discouraged and probably avoid the project. Start with a smaller, current project; then, when you can, go back and take another bite of your library of images. The important thing is to get the process started. Jack tries to register his images every three months and also whenever he shoots a big job. He doesn't always make it exactly on the three-month mark, but he makes the effort. And if he's busy that quarter then he'll register several times in that three-month period.

It's easier to register when the work is unpublished. With unpublished work, you need just one small JPEG of each image to send as the "deposit" to the Copyright Office. If the work later becomes published, you are fully protected. But with published work, you need to state the date of publication and provide two "best edition" copies of that work. You cannot mix published work and unpublished work together in a registration.

Also, you are protected with registration only if you register before an infringement. Registering after an infringement protects you only from infringements that occur after the registration date. With one exception: For published work, and only published work, you have a three-month window after publication to register and still be protected even if an infringement has already occurred.

# Who Knew? (Part 1)

Years ago a photographer in a small sleepy Southern town had a young high school graduate walk into his studio to get some standard portraits. He wanted a common package for family and friends, mostly a wallet size order, with maybe an 8x10 or two. No thought of any editorial or advertising usage entered anyone's head. Nothing special, nothing glamorous. In no one's wildest imagination would these images be seen by other than family and friends.

Some years later, Jack got a call from the photographer, Ken Knight of Franklinton, LA. Seems that the young man he photographed up and married a local girl from the Bayou state. Seems they got hitched in a fever at a marriage chapel in lovely Las Vegas, NV. A very common, oft-told tale except for the blushing bride's name—Britney, Britney Spears.

The photos of the wedding ceremony itself were subject to a big buck media exclusive. They were not therefore, available to the general news media. Instantly there was an insatiable demand for images of the new groom by the general worldwide media. Since the young lad was not in show business and had yet to do anything newsworthy, nobody had a photo of him.

The stock cupboard was bare and hysteria spread to stock agencies, networks and media conglomerates throughout the land. They all wanted to see a photo of the guy Britney chose to marry. What did he look like? Suddenly and quite magically, Ken's image was everywhere. But Ken wasn't getting paid for his photo and no one had asked for his permission to run it.

During their phone call, Jack asked Ken the first question that is always asked, "Is the image registered?"

The answer, as usual, was "No." Uh oh. "Better talk to Ed Greenberg, a lawyer, right away," advised Jack.

By chance, Ed was in Washington, DC on another photography case. Good timing and good luck for Ken, who sent the registration materials directly to Ed in DC. Ed then walked the registration through the copyright office and obtained an "expedited registration." Because of that registration, lawsuits were filed against various media companies—all of which were eventually resolved to "the mutual satisfaction of the parties." All we can say is that Ken is very happy he called Jack and had the image registered right away. Who knew?

So, if a photo is published on January 1st, and it remains unregistered until someone infringes it on February 1st, then as long as you register it as published by April 1st, you will be fully protected against the prior February 1st infringement. If you wait until April 2nd, then you are one day beyond the three-month window of protection. Just to emphasize and reiterate, this is only for published work, and it's a three-month window—not a 90-day window as sometimes described. The law is stated as three months, so January 1st to April 1st is three months, no matter how many days are in between or if it's a leap year. Just like your birthday is always the same date every year, no matter how many days in between (365 or 366).

Let's look at the same scenario, but this time the work is not published. You create the work on January 1st. It is infringed on February 1st. You register it February 2nd, a day after the infringement. You are not protected. Sorry, but that's the way the law is written.

Basically (with the notable exception for published work), register today and you are protected for tomorrow, but you were not protected yesterday. You might want to read that all again slowly. Listening to Jack and Ed explain this material in their lectures is like listening to Abbott and Costello doing their "Who's on First?" routine. Trust us, your hair will stop hurting soon. It does eventually make sense.

As stated above, it's easier to register your unpublished work and be protected in advance. If you register a work as unpublished, you are still protected if it is published at a later date. But if you publish a work first and then register it later, it must be registered as a published work, which requires a few extra steps in the process (see page 61). A notable exception is if the work is published without your knowledge. In that case, the courts will respect your unpublished work and its registration.

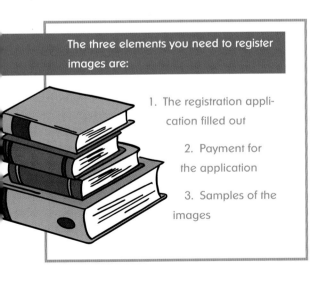

**The three elements you need to register images are:**

1. The registration application filled out

2. Payment for the application

3. Samples of the images

# WHAT QUALIFIES AS FAIR USE?

Copyright law gives the creator the exclusive rights to reproduce, distribute, and publish their work and/or grant one or more of those rights—via a "license" or permission—to others such as publishers and filmmakers. Typically the creator receives a fee (money) from someone obtaining one or more of the rights the creator by law possesses. In a sense, the creator owns a monopoly on the work but there are exceptions to this absolute control.

One exception is known as "fair use," and it is mistakenly asserted about as often as it is legitimately relied upon. The concept green-lights the efforts of a non-author to copy, publish, or distribute certain copyrighted works without the consent of the creator or registrant for purposes such as commentary, news reporting, education, or scholarship. Historically, copyright law has always been about a "balancing act" between the benefits to society and the rights of creators.

There is no cut-and-dry, black-and-white, mileage-chart method to conclusively determine whether a use definitively qualifies as a "fair use," and thus permissible without the author's consent. The law does, however, set forth certain key factors in order to be able to adjudicate each dispute on a case-by-case basis:

• Whether the nature of the use was for commercial use or for nonprofit, educational purposes

• The nature of the work itself

• The amount of the work appropriated (was the whole work taken or a small portion?)

• The effect of the use upon the potential market or value of the appropriated work

The above four factors are not the only factors a court will examine in such cases. There have been thousands of cases in the court system over the last 30+ years where lawyers and judges bashed heads.

WARNING: These cases are always fact- and judge-sensitive.

# historical briefs -1700s-

## The Statute of Anne

Along with new writers came those who profited from their labors. No, not agents (they came later, in swarms, like locusts), but publishers. Novels were originally printed in installments—by the chapter, not by the book; and publishers paid authors per chapter. (Ever wondered why there are so many chapters in Dickens' books?) What happened next is what prompted copyright law: Unscrupulous, rogue publishers would obtain a copy of the latest Dickens installment and have their printer make copies to sell. Since these publishers didn't have the overhead of author royalties, they could undersell the legitimate publisher. Not at all thrilled by getting ripped off (long before that phrase came into existence), the original publishers and the authors themselves successfully petitioned Queen Anne. The result was the original copyright law, passed in Britain in 1710, named The Statute of Anne. It began with the words, "An Act for the Encouragement of Learning," which is notable for Americans because, in 1787, the same idea was written into the United States Constitution, which uses the words, "to promote the progress of science and useful arts."

# Who Knew? (Part 2)

Jack photographs kids for large companies, typically licensing the images for national consumer usage. One day, Jack gets an angry call from an art director asking why Jack licensed one of the kid images, for which they hold the license, to an online discount coffee website.

"Who, me?" Jack responded—a phrase well known by every married man. "Never!" He might re-license an image, as is his right, after the licensed use is over. But Jack made clear to the art director that he did not and would not license the image during the term of his client's license.

Jack's client had discovered the infringement purely by chance; an employee who was shopping via the Internet recognized Jack's image on the coffee website. Jack immediately advised his client that he would contact his lawyer to have the offending image taken down.

Jack sent Ed a copy of his copyright registration and Ed proceeded to write the dreaded "lawyer's letter," the kind no one wants to receive, with the registration attached. While Jack is an artist with the camera, Ed is just as much an artist in his own right at drafting those letters. That letter requested that the image be taken down and a written accounting of the full nature and extent of the offending use be sent to us ASAP. When received by the offender the image was removed almost immediately. Essentially their position was that since they had removed the infringing image, Jack's problem was solved. Sort of, "OK, you caught us and we took it down, so no harm and no foul. Why make a federal case out of it?"

Letting an infringer off without seeking damages would encourage that infringer and all future infringers to assume a catch-me-if-you-can attitude. They could simply continue to rip off images because there would be no deterrent to keep them from doing so. Under the copyright law, Jack had certain rights as the author of a registered work. Included among those rights is the ability to sue for money damages irrespective of whether or not any profits were generated. Jack likened the infringement of his work to being stabbed in the chest with a serrated knife. Simply saying, "Whoops, my bad" does not itself heal the wound. Nor would merely taking the infringing image off the website be the end of this story.

The defendant represented itself as a small, mom-and-pop operation with a handful of family employees. But their mom-and-pop operation was marketing name-brand products throughout the country, and apparently making a profit. Whether a business is profitable or has profited from an infringement does not determine whether an infringement has occurred. In infringement cases, we prefer dealing with experienced Intellectual Property (IP) lawyers who understand the risks and rewards of litigation to both sides. Scare tactics or dares used by inexperienced lawyers typically backfire. Rather than resolve the matter without resort to litigation, this defendant in effect dared Jack to sue. So he did, in federal court in his hometown of New York City.

We want to make it clear that prosecuting a copyright infringement case is no walk in the park. Taking oral depositions is just one part of the process. Ed would depose the website owners, and their lawyer would depose Jack. Ed prepped Jack for his deposition. Let's just say that many of Ed's clients get really peeved at Ed after he preps them—a fact of which Ed is quite proud. The prep session is basically involves getting grilled like a chicken on a summer barbecue and being bombarded by a hurricane of questions. If you are properly prepared when an opposing lawyer questions you,

the experience can be like a walk in the park. Instead of looking like a deer in headlights, you now sound like Sir Lawrence Olivier. Don't worry, Jack has long forgiven Ed for that deposition prep he went through. Well...sort of.

After his prep, knowing Ed was going out to St Louis to depose the infringing couple, Jack almost felt sorry for them. Almost, but not quite. You see, the defendant's own website bore a copyright notice. Even though Jack's image had been misappropriated, mom and pop knew enough to register and protect their site. This opened the door at the deposition for questions all aimed at why this defendant would violate the rights of a creator while at the very same time seeking to preserve those very same rights for themselves! You can't make this stuff up.

With the amount of the monetary settlement that was paid, we are fairly sure they have not and will not be infringing anyone else's work. Good.

All of this was only possible because Jack had registered his image, long before the infringement occurred. Without the registration, this lovely story with a happy, income-producing ending would likely have not ended well for Jack. Without a proper registration, you simply cannot file in court and get the remedies allowed by the law. Luckily, Jack knew that.

# Registration Walkthrough

We've talked about why you should register your photos until we're blue in the face (see photo). Now, we'll hold our breath until you do register your work (see same photo). Here's how to register.

This walkthrough will only cover the eCO (Electronic Copyright Office) system. The old paper VA (Visual Arts) forms cost almost double per application ($65 vs. $35 for the electronic filing) and take about a year or more to get the registration back. So we highly recommend sticking with electronic filing. After you do it once, it really does become fairly easy.

There are basically three steps to registering your work with the eCO system: filling out the application; paying for it via a direct link to the US Treasury; and finally, sending in your images by either uploading them digitally or mailing them in. The great advantage of registering via eCO and then uploading your images is that your registration becomes effective immediately. If you mail them in, the effective date is when the Copyright Office receives the images in their mailroom—how 20th Century! That will delay the effective registration date.

The effective date is important, as that's the date your registration protection starts. If you are infringed before the date of the registration, then it's like not being registered at all. But if any infringement occurs after that date, then you're covered. The effective date of registration is the day that the Copyright Office receives all the elements of your registration, regardless of how long it takes the Copyright Office to process your application, or how long it takes for you to receive the registration certificate. That could be two months, three months, or even a year. Again, the three required elements are: the application, the payment, and the images themselves (files, prints, contact sheets, or whatever).

To start registering your work, go to the www.copyright.gov site. Just so you know, if you go to the copyright.*com* site, you end up not at the copyright office, but at a commercial site that's trying to sell you something. So make sure you start at the copyright.*gov* site. Remember, this is a government site and the interface was most likely built by the lowest bidder, so don't expect a sleek, flashy design. From our own many registrations we've learned the ins and outs, quirks and potholes, and can now give you a buffet of helpful hints that will keep you from pulling all your hair out (see any photo of Ed).

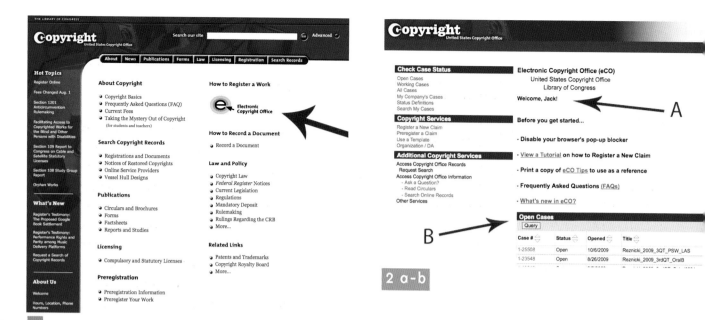

While there is a lot of good info on this initial page (**Screen 1**), for registration you need to follow the link to the Electronic Copyright Office found under the *How to Register a Work* heading. You can skip the subsequent several pages that advise you that the system is a public record, filing a false registration is a crime, and other info.

If you are a first-time user, you need to create a Username and Password when you get to the sign in page. This is the page we recommend you bookmark, so you can start here next time, and skip over all the previous screens. Your password must contain letters, numbers, and at least one "special" symbol, like "$" or "%" or "!"—so a password for Jack or Ed might be JackShoots$5000 or EdWillSue!x2. If you already created a username and password previously, just sign in.

After putting in your username and password, you will finally find yourself at the eCO front page (**Screen 2**). We like that they greet you here—in this example, "Welcome Jack!" (**Screen 2—A**). If you have any open or working registrations, called "cases," you will see them listed at the bottom (**Screen 2—B**).

## The description of the status of your cases according to the Copyright Office is as follows:

**1. Open:** These are cases currently being processed by the Copyright Office. "Open" means you can still upload images in that registration. That ability is closed when an inspector begins your registration at their end. The date of your most recent upload will be the effective

date of the registration. You should be very careful with this. If I start a registration and upload all my images on January 1st, and the inspector starts my case on March 17th, then the effective date of my registration is January 1st. However, if I decide to upload a few more files on March 1st on a registration that was started on January 1st, then the effective date of my registration will now be March 1st, the date of my last upload.

**2. Working:** These are cases that you have started registering, but were stopped before the application was completed, or for which payment has not yet been submitted (i.e. you haven't placed the application in your Cart).

**3. In-Cart:** These cases are in your Cart awaiting payment and are not yet submitted to the Copyright Office. You've completed the application for them and are either in the process of paying, or waiting for confirmation from the Treasury that payment was made.

**4. Closed:** These cases have been completed by the Copyright Office. The application is done and your registration is either on its way, or you already have it in hand. To view closed cases, click the *All Cases* link on the upper left of the eCO front page.

**5. Discarded:** These are cases that you want to remove from your case history. You can still view discarded cases by clicking on the *All Cases* link.

*Helpful Hints*

If you are using a Mac, you can't use the Safari browser. You must use Firefox or Internet Explorer (IE). If you are on a PC, you can obviously use IE or even Firefox. But Safari is still a no go. There are also some prompts you should read if you are on Firefox, which have to do with setting your preferences. It reads: "Firefox 2.0 users must adjust the Tabs setting to 'New pages should be opened in: a new window.' The Tabs setting is under Tools/Options in Firefox 2.0 for PCs; the Tabs setting is under Preferences in Firefox 2.0 for MACs." OK, so their instructions are a little behind in software versions, but the preferences are still the same for all the current versions of Firefox. It takes a while for government sites, which work under tight budgets, to update such stuff.

For all browsers, you should disable the pop-up blocker. Also disable any 3rd-party toolbars (e.g., Google or Yahoo Toolbar). And finally, set your security and privacy settings to MEDIUM.

Do not use the forward and back buttons on your browser once you start your registration. This will cause the registration program to self-destruct. You need to navigate using the program's *Next* and *Back* buttons. There is also a *Save For Later* button, which will stop your registration at that point and save everything you've done so far. Then you have to start at the front page again and navigate back to where you were via the *Next* button. Quite kludgy, we admit.

# FILLING OUT THE APPLICATION

OK! You're signed in and have your browser preferences set, so you can finally start a registration. Under the Copyright Services heading, click on *Register a New Claim* (**Screen 2—C**). After you've gone through the registration application process once, you can save what you did as a "template." A template will save you a lot of time with future registrations. You may find the registering process to be cumbersome, clunky, and time-consuming, but after your first time, especially if you utilize a template, it'll be a breeze. If you have previously created a template, then you can click on *Use a Template*.

## Note:

Be careful with templates, as they will use all the same info from a previous registration. When a template is created, the information is repeated automatically and there are some fields you will need to change. You have to be sure to eliminate the old title of your work and give it a new title; otherwise you may end up with the same title as your previous registration, which can create problems. Using a template will save you a lot of time, but carefully review each application before payment.

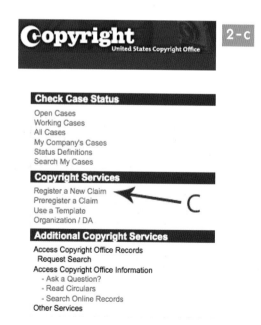

Once you start, you will go to the *Type of Work* page (**Screen 3**) and see a shaded navigation box on the left, with the 11 steps of the application process. It will highlight in red which step you are currently working on, and give you an idea of where you are in filling out the registration application. Some steps take several pages and some are simply skipped by clicking on the *Next* button.

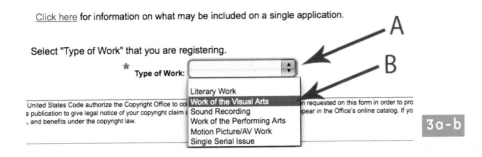

Click here for information on what may be included on a single application.

Select "Type of Work" that you are registering.

* Type of Work: [          ] ◆  ← A

← B

Literary Work
**Work of the Visual Arts**
Sound Recording
Work of the Performing Arts
Motion Picture/AV Work
Single Serial Issue

United States Code authorize the Copyright Office to co... ...n requested on this form in order to pro...
...e publication to give legal notice of your copyright claim ... ...pear in the Office's online catalog. If yo...
..., and benefits under the copyright law.

`3a-b`

The first step at the *Type of Work* page will be a pull-down menu (**Screen 3—A**). So pull it down. If you are a photographer or artist, click on the second choice—*Work of the Visual Arts* (**Screen 3—B**). Then click the *Next* button at the top of the screen (**Screen 3—C**) and to go to the *Titles* page (**Screen 4**). Click on the *New\** button to go to another screen with two pull down boxes next to two red asterisks (**Screen 5**). (Note that any red-asterisked box must be filled out.) The first asterisk says *Title Type*. The correct selection for 99.9% of the time will be: *Title of the work being registered*. Once you finish giggling at how silly that question is, go on to fill in your title in the box that says *Title of this work* and click the *Next* button.

For some reason, from the feedback we get, this next box is confusing for many people. You simply have to give a title to this registration. Anything you want. You can title it "Fred," "Wilma," or "BamBam." The Copyright Office doesn't care. It is a single title for one image or 5,000 images. You do not title every image separately, just this single registration. Jack likes something descriptive, so he knows when he shot it and what it is. A typical title for him might be "2009_3rdQT_Paris." It's obviously done in 2009, in the 3rd quarter of the year, and in Paris. It can be whatever you want.

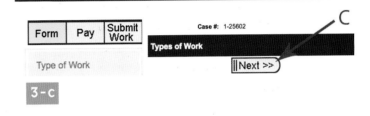

**Copyright** United States Copyright Office

| Form | Pay | Submit Work |

Case #: 1-25602

**Types of Work**

← C

Type of Work                    ‖Next >>‖

`3-c`

**Copyright** United States Copyright Office                    Home |

| Form | Pay | Submit Work |    Case #: 1-25602    Type of Case: Work of the Visual Arts    Date Opened

**Titles**

Type of Work
Titles          ‖<< Back ‖ ‖Next >>‖          ‖ Save For Later ‖
Publication / Completion    Give the title(s) exactly as it appears on the work. If there is no title, give an identifying phrase, or state "untitled".
Authors          To enter the title(s), click "New". After you enter the title, click "Save". Repeat this process for each additional title. When f
Claimants          click "Next".
Limitation of Claim
Rights & Permissions     ‖New * ‖
Correspondent          To edit or delete a title, click the appropriate link in the list below. When the list is complete and correct, click "Next".
Mail Certificate    **All Titles**
Special Handling
Certification     Title of Work    Volume    Number    Issue Date    Type
Review Submission

`4`

**Copyright** United States Copyright Office

| Form | Pay | Submit Work |    Case #: 1-25602    Type of Case: Work of the Visual Arts

**Title**

Type of Work          ‖Help‖ ‖Save‖ ‖Cancel‖
Titles          Give only one Title and Title Type at a time on this screen; then click "Save".
Publication / Completion    Step 1: Click on "Title Type" to determine the type of title.
Authors          Step 2: Select the Title Type. You must select "Title of Work Being Registered" at least once.
Claimants          Step 3: Enter the title from the work that corresponds to the Title Type you selected.
Limitation of Claim    Step 4: When you have finished adding all titles, Click "Save" to save the title.
Rights & Permissions
Correspondent     *Title Type: [Title of work being registered] ◆
Mail Certificate     *Title of this work: [PSWVegas_Hawaii]
Special Handling
Certification
Review Submission

`5`

**6**

When you are done, click on *Save* and you will go back to the front *Titles* page. Here you'll see your *Title of Work* and *Type* fields filled in (**Screen 6**). Make sure that they're correct at this point or you'll have to wade through a lot of windows to correct it later.

Click the *Next* button, and now you're on the third page, called *Publication / Completion* (**Screen 7**). You will see an asterisked box asking, *Has this work been published?* You have 2 choices: *Yes or No*. *No* means the work is unpublished and therefore, as explained earlier on page 49, easier to register. If you select *No*, you will be prompted to enter the *Year of Completion (year of Creation)* (**Screen 8**). OK, easy enough. What year did you create the work? There is another box for putting the preregistration number, but this rarely applies to photographers. It's for works being made in progress, like a motion picture where they want copyright protection before the work is completed, which could span several years.

**7**

**8**

**Copyright** United States Copyright Office

Home | 🛒 | My Prof

| Form | Pay | Submit Work |
|------|-----|-------------|

Case #: 1-256029551     Type of Case: Work of the Visual Arts     Date

**Publication / Completion**

Type of Work
Titles
Publication / Completion
Authors
Claimants
Limitation of Claim
Rights & Permissions
Correspondent
Mail Certificate
Special Handling
Certification
Review Submission

<< Back || || Next >>     || Save For Later ||

Published work? [Yes ▼]     *Nation of First Publication: [ ▼]Help

*Year of Completion (Year of Creation): [YYYY]   International Standard Number Type: [ ▼]Help

*Date of First Publication [MM/DD/YYYY]: [🔲]Help    International Standard Number: [ ]

If you have **Preregistered** your work under 17 U.S.C 408 (f) (and received a Preregistration number beginning with the PRE prefix), give the Preregistration Number here. Click here for further information about Preregistration.

Preregistration Number: [ ]

Click "Next" to proceed to the "Authors" screen.

---

If the work has been published and you select *Yes* on the initial page, you'll be prompted to enter the same *Year of Completion (year of Creation)* box, in addition to the *Date of First Publication* (to be filled out in a MM/DD/YYYY format) and the *Nation of First Publication* (**Screen 9**). The United States is the first choice in the drop-down menu, so you don't have to scroll all the way down—thoughtful of them, no?

If your photo was published in both the United States and another country on the same day, give "United States" as the nation of first publication. We're number one. There is also an *International Standard Number* box. Typically, this would be filled in if you are registering a book and have an ISBN number. For photographers, you will not have to fill that out.

Click the *Next* button and you will be at the *Authors* page (**Screen 10**). There is a *New\** button (**Screen 10—A**) and an *Add Me* button (**Screen 10—B**). The first time you're here, you must first click the *New\** button to create your template. In subsequent registrations, you can simply click *Add Me* to bring up a screen with everything already filled out.

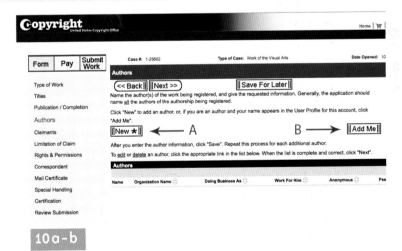

**Copyright** United States Copyright Office     Home | 🛒 |

| Form | Pay | Submit Work |
|------|-----|-------------|

Case #: 1-25602    Type of Case: Work of the Visual Arts    Date Opened: 10

**Authors**

Type of Work
Titles
Publication / Completion
Authors
Claimants
Limitation of Claim
Rights & Permissions
Correspondent
Mail Certificate
Special Handling
Certification
Review Submission

<< Back || || Next >>     || Save For Later ||

Name the author(s) of the work being registered, and give the requested information. Generally, the application should name all the authors of the authorship being registered.

Click "New" to add an author, or, if you are an author and your name appears in the User Profile for this account, click "Add Me".

||New ★|| ⟵ A      B ⟶ ||Add Me||

After you enter the author information, click "Save". Repeat this process for each additional author.

To edit or delete an author, click the appropriate link in the list below. When the list is complete and correct, click "Next".

**Authors**

| Name | Organization Name | Doing Business As | Work For Hire | Anonymous | Pse |
|------|-------------------|-------------------|---------------|-----------|-----|

**10a-b**

## Screen 11

| Form | Pay | Submit Work |

Case #: 1-25602      Type of Case: Work of the Visual Arts

**Authors**

|| Save ||| || Cancel ||

Type of Work
Titles
Publication / Completion
Authors
Claimants
Limitation of Claim
Rights & Permissions
Correspondent
Mail Certificate
Special Handling
Certification
Review Submission

Author's Name Give either an individual name OR an organization name, but not both. An author is a person who actually created the contribution, unless the contribution was "Made for hire" in which case the employer is the author. Either citizenship/domicile of the author is also required.

Individual author:          OR          Organization:
First Name: Jack          Organization Name:
Middle Name:
Last Name: Reznicki

Is this author's contribution a work made for hire ?:

* Citizenship: United States    Help          Anonymous: ☐    Help
* Domicile: United States    Help          Pseudonymous: ☐    Help
Doing Business as:    Help          Pseudonym:    Help
Year of Birth:    YYYY
Year of Death:    YYYY

**11**

## Screen 12

| Form | Pay | Submit Work |

Case #: 1-25602      Type of Case: Work of the Visual Arts      Date Opened: 10/8/2

**Authors**

Help || Save ||| || Cancel ||

Check the appropriate box(es) to indicate the author's contribution.

Type of Work
Titles
Publication / Completion
Authors
Claimants
Limitation of Claim
Rights & Permissions
Correspondent
Mail Certificate
Special Handling
Certification
Review Submission

* Author Created:
☐ Text    Help          ☑ Photograph(s)    Help          ☐ Jewelry design    Help          ☐ Architectural work    Help
☐ 2-D artwork    Help          ☐ Sculpture/3-D artwork    Help          ☐ Map and/or Technical Drawing    Help
Other:

**12**

## Screen 13

| Form | Pay | Submit Work |

Case #: 1-25602      Type of Case: Work of the Visual Arts      Date Opened: 10/

**Claimants**

(<< Back ||| || Next >> )          || Save For Later ||

Type of Work
Titles
Publication / Completion
Authors
Claimants
Limitation of Claim
Rights & Permissions
Correspondent
Mail Certificate
Special Handling
Certification
Review Submission

Please identify the copyright claimant(s) in this work. The author is the original copyright claimant. The claimant may also be a person or organization to whom copyright has been transferred.

To be named as a claimant by means of a transfer, a person or organization must own all rights under the U.S. copyright law.

In addition, a claimant must own the copyright in all the authorship covered by this registration.

Click "New" to add a claimant, or, if you are a claimant and your name appears in the User Profile for this account, click "Add Me" to add your name and address into the claimants list.

After you enter the claimant information, click "Save". Repeat this process for each additional claimant.

|| New ★ ||          || Add Me ||

To edit or delete a claimant, click the appropriate link in the list below. When the list is complete and correct, click "Next".

**Claimants**

| Name | Organization Name | DBA | Transfer Statement | Address |

**13**

## Screen 14

| Form | Pay | Submit Work |

Case #: 1-25602      Type of Case: Work of the Visual Arts

**Claimants**

(<< Back ||| || Next >> )          || Save For Later ||

claimant is doing business as (trading as, sole owner of, known as), give the name in "Doing Busin

Type of Work
Titles
Publication / Completion
Authors
Claimants
Limitation of Claim
Rights & Permissions
Correspondent
Mail Certificate
Special Handling
Certification
Review Submission

Individual Claimant:          OR          Organization:
* First Name: Jack          * Organization Name:
Middle Name:
* Last Name: Reznicki

Doing Business As:

* Address 1: 31 W. 27th St.          State: NY
Address 2: Suite 10B          Postal Code: 10001
* City: New York          Country:

If any claimant is not an author, you must include a transfer statement showing how the claimant ol copyright.

Transfer Statement:
Transfer Statement Other:

**14**

---

Since you're the creator—or in the Copyright Office's language, the "author"—fill in your name (**Screen 11**). Even if you are a photography business, we highly recommend that you do not register your images in your company name, but rather register them personally. Even though Jack is incorporated as Jack Reznicki Studio, Inc., all his images are registered to Jack personally.

Clicking *Save* will move to the second part of the *Authors* section (**Screen 12**). This is an easy one: just check the box next to *Photograph(s)*. Click *Save* again to return to the beginning of the *Authors* screen, which will now have all the necessary information filled in.

After *Authors* comes the *Claimants* page (**Screen 13**). Unless you assigned, sold, or transferred the copyright, then you as the creator/author of the work are also the claimant. So you'll need to create another profile for yourself by clicking the *New** button, just like you did in the *Authors* section (**Screen 14**). Enter all the required information, and click *Save* to return to the main *Claimants* screen. Then click *Next*.

This brings up the *Limitation of Claim* page (**Screen 15**). Easy. Just hit the *Next* button. Why in the world do you want to put a limitation to your registration? Jack has never had any reason to. There's an explanation of what this is all about on the top of the screen if you're curious. But for now, just click the *Next* button.

This is the *Rights and Permissions* page (**Screen 16**). "This is the person authorized to grant permission to use this material." Oh, look, another *Add Me* button. Unless you want someone else to have control over your images (and why would you?) input your personal info, and click the *Next* button.

Here's the *Correspondent* page (**Screen 17**). This is the person the Copyright Office will contact if it has questions about the application. Yup, another *Add Me*. You will see a red asterisk next to name, email, and address—so filling them out is mandatory.

Clicking *Next* moves on to the *Mail Certificate* page (**Screen 18**). This is the name and address to which the registration certificate should be mailed. This is usually another *Add Me*, unless you have another address you want the certification mailed to.

Next up is the *Special Handling* section (**Screen 19**). This is the $760 page. Generally speaking, just click *Next*. If you need special handling and fill out this page, it will cost you $760. The only reason you might want this is if you have an infringement and there is a court case pending. Remember, you can't file a case without the registration in hand, and this will expedite getting it into your hands. You should only consider utilizing this service under the direction of your lawyer.

Click *Next* to move on to *Certification* (**Screen 20**). This is where they remind you that filling out any false information is criminal. In fact, they even spell out the specific statute. You will be required to enter your name and check a red-asterisked box that certifies you are indeed the copyright owner. There will also be two checkboxes to state if you will be uploading your files or if you will be mailing them in. Just check the appropriate box.

Click the *Next* button, and you'll be presented with all your application information at the *Review Submission* page (**Screen 21**). This will be a summary of all the information you previously entered, all on one page. Do review it carefully, as after you leave this page, you can't change anything. If you do want to change anything at this point, you need to go back page by page using the on-screen *Back* button. No skipping. Page by page. Inch by inch. Step by step.

# SUBMITTING PAYMENT

If, after reviewing the summary, everything on your application looks correct to you, then click on the *Add to Cart* button. Once your application is "In-Cart" (**Screen 22**), then you can pay for it. To continue, click on the *Checkout* button. That will take you to the checkout page (**Screen 23**), or what I like to call the "So how do you want to pay for this?" page.

Once your application is in the cart, you can't go back to change any of the information. The cart holds the application while you get transferred to the Treasury Department to pay your $35.00. When you check out there will be a warning page (**Screen 24**) explaining that you are leaving the Copyright Office site and being transferred to the Treasury department website, so they can more efficiently and quickly move the money out of your pocket directly into the government. It seems that the most efficient arms of the government are the ones that relieve you of your money. We recommend paying by credit card, which is the second choice of payment on the screen. The first choice is to have an account at the Treasury Department to pay directly from your bank account. Unless you register a lot of things regularly, like a magazine or book publisher would, this would be overkill.

**22**

**23**

**Notice:** You are now leaving eCO - the electronic Copyright Office site, and entering pay.gov, a U.S Treasury site where you can submit your payment information. The Copyright Office does not receive or hold any credit card or bank account information submitted to pay.gov. Upon completion of your payment, you will be returned to eCO.
**Filing fees are not refundable.**

**Do you wish to proceed?**

||| Cancel |||        ||| OK |||

**24**

## Error Message

We detected an Error which may have occurred for one or more of the following reasons:

The selected record has been modified by another user since it was retrieved. Please continue.(SBL-DAT-00523)

**25**

---

**System Message** — **26**

* The system has populated the Payment Date with the next available payment date.

Online Payment — Return to your originating application
**Step 1: Enter Payment Information** — 1 | 2
This item is payable by Bank Account Debit (ACH) or Plastic Card (ex: VISA, Mastercard, American Express, Diners Club, Discover)
**Option 1: Pay Via Bank Account (ACH)** About ACH Debit
Required fields are indicated with a red asterisk *

- Account Holder Name: *
- Payment Amount: $35.00
- Account Type: *
- Routing Number: *
- Account Number: *
- Confirm Account Number: *
- Check Number:

Routing Number    Account Number    Check Number
⑆026946783⑆ 924376739 0⑈ 1234

Payment Date: 10/09/2009
Select the "Continue with ACH Payment" button to continue to the next step in the ACH Debit Payment Process.
(Continue with ACH Payment) (Cancel)

Note: Please avoid navigating the site using your browser's Back Button - this may lead to incomplete data being transmitted and pages being loaded incorrectly. Please use the links provided whenever possible.

**Option 2: Pay Via Plastic Card (PC) (ex: VISA, Mastercard, American Express, Diners Club, Discover)**
Required fields are indicated with a red asterisk *

- Account Holder Name: *
- Payment Amount: $35.00
- Billing Address: *
- Billing Address 2:
- City:
- State / Province: *
- Zip / Postal Code:
- Country: United States
- Card Type: VISA MasterCard AMEX Diners Club DISCOVER
- Card Number: * (Card number value should not contain spaces or dashes)
- Security Code: * help finding your security code
- Expiration Date: */ *

Select the "Continue with Plastic Card Payment" button to continue to the next step in the Plastic Card Payment Process.
(Continue with Plastic Card Payment) (Cancel)

Note: Please avoid navigating the site using your browser's Back Button - this may lead to incomplete data being transmitted and pages being loaded incorrectly. Please use the links provided whenever possible.

---

While you are going to the cart or to checkout, you may encounter an error message (**Screen 25**). Don't freak out. For some reason this seems to come up a lot, and from what we can tell it doesn't mean much. But it can be frustrating if you don't know that the error message itself is usually just an error. Hopefully they'll fix this soon. If you get stuck and can't go on or checkout, hit *Home* on the mini toolbar at the upper right of the page, and go through the screens until you get back to the checkout.

When you get to the payment page, you'll see that it's a standard online payment form (**Screen 26**). After you fill out your credit card info, you'll get another screen asking if you want email verification (**Screen 27**). Do sign up for verification, just on the rare chance there is a problem getting your registration materials to the Copyright Office. You can't proceed with your registration until the Copyright Office gets payment confirmation from the Treasury Department. The Treasury site warns it could take a while to get the confirmation to the Copyright Office, but in our experience, it happens in seconds. To repeat: they are very efficient at getting your money.

---

**27**

Online Payment — Return to your originating application
**Step 2: Authorize Payment** — 1 | 2
**Payment Summary** — Edit this information

| Address Information | Account Information | Payment Information |
|---|---|---|
| Account Holder Name: Jack Reznicki | Card Type: American Express | Payment Amount: $35.00 |
| | Card Number: ********** | Transaction Date 10/08/2009 12:05 and Time: EDT |
| Billing Address: | | |
| Billing Address 2: | | |
| City: New York | | |
| State / Province: NY | | |
| Zip / Postal Code: | | |
| Country: USA | | |

**Email Confirmation Receipt**
To have a confirmation sent to you upon completion of this transaction, provide an email address and confirmation below.

- Email Address:
- Confirm Email Address:
- CC: — Separate multiple email addresses with a comma

**Authorization and Disclosure**

Required fields are indicated with a red asterisk *

I authorize a charge to my card account for the above amount in accordance with my card issuer agreement. ☐ *

Press the "Submit Payment" Button only once. Pressing the button more than once could result in multiple transactions.
(Submit Payment) (Cancel)

Note: Please avoid navigating the site using your browser's Back Button - this may lead to incomplete data being transmitted and pages being loaded incorrectly. Please use the links provided whenever possible.

# Sending in your Images

Once you have paid and it's confirmed, you can proceed with the last third of the registration process: the image deposit. If you previously marked that you will mail in the images—or, as they call it, the deposit—then you will print out a shipping slip to include with your images on CD, DVD, contact sheets, or whatever. That way when they get your images, they know to which application it corresponds.

If you are going to upload, it's best to start at the *Home* screen again. There you will see the case number of your current application (**Screen 28**), along with any other cases you have working. Click on the case number, which should be in blue, and it will take you to the upload page (**Screen 29**). There is a button to upload your images and a button to mail in your images. You have 30 days to send in the images if you are mailing them in. If you click on the *Send by Mail* button, you will be able to print out a shipping slip to be

included with your image deposit. It is not a mailing label—you have to print out the mailing or shipping label with the Copyright Office's address yourself. That address is on the shipping slip:

Library of Congress
Copyright Office
101 Independence Avenue, SE
Washington, DC 20559-6211

28

29

# Resizing Images for an Upload

Jack runs a Photoshop action to resize and prep his files for registration:

• Open an image in Photoshop.

• Open the Action panel.

• Start an Action Folder by clicking on the "Create new set" icon at the bottom of the Action panel; it's the one that looks like a folder. Name your new Set "Copyright."

• Click on the "Create new action" icon at the bottom of the panel; it looks like a page with one corner turned up. Name it "Copyright Resize and Save," or anything else that you'll remember.

• Go to *File>File Info...* Fill out as much as you want, but if nothing else, make sure you go to the dropdown menu that says "Copyright Status" and change it from the default "Unknown" (which we hate as a default) to "Copyrighted." This will add a small © icon to your file title when you view it in Photoshop. And also put your name where it says "Author." Click OK.

• Go to *Image>Image Size...* Make sure the "Re-sample Image" button toward the bottom of the dialog panel is unchecked. Set the Resolution to 72 pixels/inch (ppi). Click OK.

• Go to *File>Automate>Fit image.* Set the parameters to constrain the file at 800 pixels on both the width and the length. That will make the longest side of your file 800 pixels long, no matter if it's a horizontal or vertical file. Click *OK*.

• Go to *Filter>Sharpen>Smart Sharpen...* Set the Amount to anywhere from 25 to 60, depending on you taste. Click *OK*. We do this because downsizing a file throws out pixels and makes the file less sharp. Don't worry too much about this, as sharpening is an entire book by itself. Smart sharpen is quick, easy, and does a great job for this function.

• Go to *File>Save As...* When the dialog box opens, create a new folder wherever you want. Jack puts his on his desktop. Save the file as a JPEG, and move the Image Quality slider to a compression level of 5 or 6. Click *OK*.

• Now this is a very important step most that most people miss or just forget: At the bottom of the action panel you will see a red ball at the bottom. That means the action function is still recording. Click on the square box to the left of the red-ball recording button. That will stop the action.

• Go to *File>Automate>Batch.* Make sure the Set and Action boxes are "Copyright" and "Copyright Resize and Save," respectively (or whatever you named them). At "Source," choose the folder holding your files waiting to be registered. Now check the "Suppress File Open Options Dialogs" and the "Suppress Color Profile Warnings," as these will only slow you down or mess up your action. Since we didn't open the original file until after we started recording the action, you do not need to click on the "Override Action 'Open' Commands." At the very bottom, make sure the "Errors" box is set for "Stop For Errors." Click *OK*.

That's it. When it's done, you'll have a folder of properly sized files, ready to upload to the Copyright Office. And once you have an action, you can use it over and over. After the initial setup, it's a great tool and a real timesaver.

## Electronic Deposit Upload

**Before you upload an electronic copy of your work:**

- Verify that it is in an <u>acceptable category for upload</u>. If it is not, CLOSE this window and click the SEND BY MAIL link in the Deposit Submission table.

- Verify that it is an <u>acceptable file type</u>.

- Verify that it is an <u>acceptable file size</u>. Be aware that each upload session is limited to 60 minutes. See <u>FAQs</u>, for guidance on uploading large or multiple files.

- Enter a brief title (or description of work in this file) for each file, using only alphanumeric characters.

Click the Browse... button to locate and select a file to be upload.

| * File Name | | * Brief Title (or description of work in this file) |
|---|---|---|
| /Users/jackreznicki/Desktop/CopyrightJPEGs.zip | Browse... | Upload1 |
| | Browse... | |
| | Browse... | |
| | Browse... | |

( Add more files... ) ( Submit Files to Copyright Office )

**30**

If you are taking the easier road and uploading your files, click on *Upload Deposit* and you will see the *Electronic Deposit Upload* window (**Screen 30**). Click *Browse* to locate the files you want to upload, and then input a title in the *Brief Title (or description of work in this file)* box. You can put any title in this field; its purpose is simply to label and distinguish your uploads. Jack labels his simply Upload 1, Upload 2, and so on.

## Electronic Deposit Upload

**Before you upload an electronic copy of your work:**

- Verify that it is in an <u>acceptable category for upload</u>. If it is not, CLOSE this window and click the SEND BY MAIL link in the Deposit Submission table.

- Verify that it is an <u>acceptable file type</u>.

- Verify that it is an <u>acceptable file size.</u> Be aware that each upload session is limited to 60 minutes. See <u>FAQs</u>, for guidance on uploading large or multiple files.

- Enter a brief title (or description of work in this file) for each file, using only alphanumeric characters.

Click the Browse... button to locate and select a file to be upload.

| * File Name | | * Brief Title (or description of work in this file) |
|---|---|---|
| | Browse... | |
| | Browse... | |
| | Browse... | |
| | Browse... | |

( Add more files... ) ( Submit Files to Copyright Office )

**31**

*Helpful Hints*

First, if you don't get prompted with the *Electronic Deposit* Upload screen, chances are you didn't disable the pop-up blocker. You have to allow pop-ups to see this window. The second hint, and one that took up a half hour of Jack's life that he'll never get back to figure it out, is that most of the time, if not all of the time, this next window comes up truncated (**Screen 31**), meaning you only see half the window. Either manually expand it horizontally or, if you can, hit the "expand window" button on top of the browser window. That will be the green button on a Mac or the double-window button on a PC.

The Copyright Office will accept a wide variety of files (see sidebar on page 70), but if you are uploading a lot of images, send in JPEGs compressed into either a .zip or .cab file. You really don't want to send in hi-res files unless they are needed for some specific reason. We recommend images at resolutions of no more than 800 pixels on the longest side, at 72ppi, with a compression of 5 or 6. The records at the Copyright Office are public information—anyone can go in and look around. Now, you'd have to be a pretty stupid criminal to steal a copyrighted, registered image from the Copyright Office; but if you read the papers at all, you know there is no shortage of stupid criminals. Why tempt fate? Your image file has to be just big enough to be reproduced in court if you have an infringement case.

The following file types
are accepted by the Copyright Office:

.bmp (Bitmap Image)

.dwg (AutoCAD Drawing)

.dwf (Autodesk Design)

.fdr (Final Draft)

.gif or .giff (Graphics Interchange Format)

.jpg, .jpeg, or .jfif (Joint Photographic Experts Group)

.pdf (Portable Document Format)

.pic or .pict (Picture File)

.png (Portable Network Graphic)

.psd (Photoshop Document)

.pub (Microsoft Publisher)

.tga (Targa Graphic)

.tif or .tiff (Tagged Image File Format)

.wmf (Windows Metafile)

You will sometimes see that your upload status is "Pending." Your uploaded files are first captured in a server that resides outside the eCO system's network firewall, where they are scanned and "scrubbed" of malicious code before being released. The status of uploaded files remains "Pending" until they are received by the eCO system inside the firewall. Once inside the firewall, the status of an uploaded file changes to "Received." This all happens fairly quickly.

## Upload successful

The following files were successfully uploaded for service request 1-25602 :

- CopyrightJPEGs.zip

Please note the service request number above for future reference.

( Close Window )

| Estimated time left: | 27 min 43 secs (974 KB of 156429.3 KB uploaded) |
| Transfer Rate: | 93.5 KB/sec |

32

**Helpful Hints**

There is a warning that you have a 60-minute time limit to upload your files. That is technically correct. But what they don't tell you is that you can do as many 60-minute upload sessions as you need. When Jack registers thousands of images on a single application, he finds that he can safely have about 750 small JPEG files in a zipped folder. Each folder then takes about 20 to 45 minutes to upload, depending on his Internet connection. He's done as many as 8 separate upload sessions on a single application. There is a progress bar (**Screen 32**) that shows up with an estimated time when you start uploading. You will need to experiment to see how many you can fit into a zipped (.zip) folder, as your mileage may vary.

You can queue up several folders, but they will continue to upload, one after the other, and it will kill your time-limited session. It will not stop between queued folders. So it's easier to queue up one folder, upload it, and then start up another. After each successful upload session you will get an *Upload Successful* window (**Screen 33**). Hit the **Close Window** button, go back to the home page, click on the case number again, and that will return you to the upload window. Then repeat the steps to upload the next batch. You can also go back on another day to continue uploading, but just remember: the date of your last upload will be the effective date of your registration.

## Certificate of Registration

This Certificate issued under the seal of the Copyright Office in accordance with title 17, *United States Code*, attests that registration has been made for the work identified below. The information on this certificate has been made a part of the Copyright Office records.

*Marybeth Peters*

Register of Copyrights, United States of America

**Registration Number:**
**VAu 993-363**

**Effective date of registration:**
June 30, 2009

---

**Title**

**Title of Work:** Reznicki_SVA_Reg

**Completion/ Publication**

**Year of Completion:** 2009

**Author**

■ **Author:** Jack Reznicki

**Author Created:** photograph(s)

**Citizen of:** United States          **Domiciled in:** United States

**Copyright claimant**

**Copyright Claimant:** Jack Reznicki

31 W. 27th St., Suite 10B, New York, NY, 10001

**Rights and Permissions**

**Name:** Jack Reznicki

**Email:** jack@photonews.net          **Telephone:** 212-925-0771

**Address:** 31 W. 27th St.
Suite 10B
New York, NY 10001

**Certification**

**Name:** Jack Reznicki

**Date:** June 30, 2009

Page 1 of 1

---

That's it! It seems like a lot the first time you do it, and will probably take some time to complete the first time around. But after that, you'll find that it really flies and you can do it all very quickly. Now all you have to do is wait to get your certificate in the mail (see above). It's such a great and empowering feeling when it comes. Jack keeps a "Copyright" folder of all his files by application title. When he get his registration form, he appends the registration number to that appropriate folder name so he can maintain a record of what file is with which application. It could prove very costly to have the Copyright Office retrieve that information from their files. It's much easier, more efficient, and extremely cheaper to maintain those records yourself.

# Release Me!

Ad agencies, clients, and others who use your images and who write your name on the "pay to the order of" line of their checks insist upon releases. Their insistence is cultivated by many well-paid lawyers who spend many billable hours protecting their clients (and their own jobs). They insist upon these releases for good reasons. When attorneys agree on anything there is probably something to it. There is no reason to ponder the musings, thoughts, or comments of bloggers and fellow photographers who are simply not lawyers. They come up with all sorts of reasons, explanations, and dances as to why you don't really need releases. They are not correct. You want to focus on taking pictures and making a living. Your business health should not be dependant on urban legends and myths.

# Model Release Myths

Non-expert experts thrive on the Internet these days, perpetuating myths instead of facts. Photographers, prone to accept the unvetted, anecdotal experiences of their non-lawyer comrades, vacuum these myths up, generating even more business for lawyers. Ed's wife says he should thank these non-experts for doling out advice; she wants a new car. What follows are some of the most common factoids—statements that may contain a germ of truth, but are in fact not facts, and are therefore likely to be misleading and deceptive.

• Factoid: "Most disputes regarding model release never go to court." This factoid is intended to give you peace of mind. It shouldn't. Let's dissect the phrase "go to court." If it means an actual trial to verdict, the statement is accurate. The reason why relatively few such cases are taken to verdict is that the law is so crystal clear that typically the only issue at play is not if there's been a violation, but who is going to pay and how much. Clear cases get settled; settled cases do not, for the most part, become part of the public record. Unlike most lawsuits and most football games, the winners and losers in model release cases are fairly easy to predict and predictable results create settlements. Best estimates are that 95 percent of all cases of all types (including divorce, personal injury, etc.) are settled or ended without a trial.

• Factoid: "The need for a model release may be dependent upon how much coordination goes into the shot." Not hardly. You are also told that whether public space is used for the photo may be a factor, as well as whether the subject is photographed in a controlled environment where access is restricted. In the state of New York and other jurisdictions these so-called factors have little to no relevance in court when determining liability. For example, say a photographer happens to see and photograph Michael Jordan crossing Fifth Avenue in New York City in the midst of, say, 500 people. He takes the picture, and it's subsequently used to advertise or promote a product, service or organization—without Michael Jordan's written consent. If Michael happens to have endorsement contracts, (we think he probably does) he might sue the photographer for interference with a contractual relationship, in addition to bringing a legal action under the Civil Rights Law—as anyone can.

• Factoid: "Some form of payment or tangible benefit must be received by the person in the photo in order for a release to be valid." As the song goes, "it ain't necessarily so." In New York, for example, consideration is specifically not required. You do not have to give the model a print or even pay them a single dollar in order for the release to be in effect. You do need their signature on the release.

• Factoid: "You don't need a release if the person isn't a professional model." Wrong. Liability is not dependant upon the job description listed in the subject's tax return. Models who earn income from modeling will likely recover more money than civilians because they can probably demonstrate greater financial damages. But sometimes a civilian can collect far more than even a supermodel. An orthopedic surgeon who happens to be a team doctor for the New York Jets, and whose photo is employed without consent in an ad promoting a branded pain reliever, will likely recover far more money than virtually any professional model whose image was used without consent in the same type ad.

• Factoid: "Property releases aren't required by law." Trademark issues aside for the moment, maybe they are, and maybe they're not. But you shouldn't take the chance. Ed's been involved in more than a few cases where money changed hands due to the lack of a property release. Location releases may also serve to protect a photographer by establishing his legal right to be at a given place at a given time for the purpose of creating certain imagery. In any event, and like it or not, most major stock and ad agencies require them. Overkill? Maybe. But it doesn't matter. No property release, no money to you. Property release in hand, you get paid. Choose wisely grasshopper.

## case studies — A Run on the Bank

A bank asks its employees to remain after closing if they want to be included in advertising materials to be distributed for the bank's promotion. It is made clear that they have no obligation to hang around, and no releases are signed. Some employees choose to remain and participate in your standard everyday location shoot with a photographer, assistant, hair and makeup person, art director, and the all-important caterer. They pose, and the shoot takes several hours. Ads and promos come out. Some employees—having never signed anything expressing their consent—claim violations of NY law. They win.

Lesson: While the employees' behavior demonstrated consent, the statute specifically stated that written releases were required. A clearly written law trumps the impressions, assumptions, and beliefs of any photographer.

# What Are the Odds?

Once upon a time, a young Kenyan woman was employed in a major Kenyan restaurant. A high-end fashion photo crew came into the restaurant prior to embarking on a weeklong location shoot. The photographer loved the young Kenyan's food and invited her along to cook for the crew during their shoot. Over the next few years she went on to accompany various crews on several photo shoots, and even became a prop stylist, as she was familiar with local garb and customs.

Several years after her last shoot, she found herself newly married and living in New York City. One day she went to Bloomingdale's, where she saw her own image on an expensive fragrance label. She bought the fragrance, took it home, and proudly showed it to her husband—who happened to be a prominent employee of a large advertising agency. Her husband called an attorney—Ed. Ed wrote one of his famous demand letters and had it hand-delivered to the photographer who had taken the image and licensed it without a proper model release.

The photographer had made a big mistake, and he knew it. He called Ed and confessed, "I'm a jerk, I know better."

"So why didn't you get a release?" Ed inquired.

*HIS ANSWER:* "What were the odds of a Kenyan cook, in the middle of the African jungle, coming to New York, marrying someone in advertising, and then walking into the one and only store in the entire United States of America that sold the product?" We have no idea what the odds were and frankly my dear, we don't give a damn. What we do know is that a very substantial settlement was paid to the young lady from Kenya.

It really doesn't matter what the odds are; with a signed release in hand, you're protected. Without a release, the odds shift and you may well find yourself putting everything you own at risk. "Signed" is the key word here. A verbal okay to use a person's likeness in your photo is an invitation for problems in the future. Who said what, to whom, when, and where can always serve as fodder for lawsuits. It's easy to dispute an (alleged) oral agreement—ask anybody who is married or has a child; it quickly becomes a he said-she said situation. But it's hard to deny the contents of a written and signed release. So always get one.

# New York State of Mind

Mark Twain said, "The trouble with the world is not that people know too little, but that they know so many things that ain't so." And so it is with the subject of model releases. There are so many myths, misconceptions, and falsehoods flying around concerning releases that straightforward, simple rules by which to work and live have become obscured. Remember: it takes less time to obtain a signed model release than it does to think about whether you need to obtain a signed model release.

Obtaining and retaining model releases will always, without exception, keep your business on an even keel. The problem is, there is no "one size fits all" model release law. Every state has a different law or statute regarding model releases and their requirements differ. For instance, Illinois law specifically requires "a writing." In legalese "a writing" may be a document that lacks many of the formalities of a full-blown contract. In contrast, under Florida law there are some exceptions to the need to have a written model release. Generally speaking, if your image appears in NY State, NY law applies; if your image appears in Minnesota, Minnesota law applies, and so on. These state statutes are in effect to cover use in that respective state. Typically, if you shoot a wedding in state A, you only have to worry about state A's statutes. But if you now run an ad in *Brides* magazine—a publication that will appear in all 50 states—you have to have a release that covers you for all state statutes.

That's actually very easy if you have a well-written and properly executed release. If an image is used in the state of New York, the New York Civil Rights Law Sections 50, 51 require (under criminal penalty in some cases) that if the photo, portrait, or likeness is to be used for trade or advertising purposes, a "writing" signed by the subject authorizing such use is required. That "writing" may take the form of a release, a modeling agency voucher, a contract, an agreement, or any other duly executed writing. The model release forms in the back of this book are all in accordance with New York requirements.

# MODEL RELEASE
# FINE PRINT

The specific requirements for model releases vary from state to state, so be to absolutely safe you should consult a lawyer on your particular state's statute. Note that some states have statutes containing very specific, unambiguous language that can be easily understood by anyone; New York is one example. Since most published works, magazines, and ads appear in the state of New York at one time or another, many clients require that your model release satisfy New York law. No matter where the image was taken, retouched, or printed, if the image is shown in NY, it needs to satisfy the crystal clear NY statutes. What matters is where it appears, not necessarily where the image was shot.

Generally speaking, you are required to obtain the written permission of a subject for his or her inclusion in any image used for advertising, promotional, or trade purposes—regardless of whether the photo is used by a for-profit or not-for-profit entity. In this respect, a photo employed in Red Cross advertisement is no different than an ad to sell Dell computers. Images from wedding and portrait work should be released if you intend to use them on your website, in your blog, as a display in your studio, for self-promotion, or in a mailer.

Images used for editorial or certain fine art uses generally do not require a written model release. To claim editorial use, the image must be newsworthy in and of itself, and can't be primarily used for commercial purposes (see more on pages 86-87). Likewise, don't assume you can call your image a work of "fine art" and thus avoid the need to have a model release. In the event your subject objects to such use, a court may closely—and we mean closely—scrutinize your fine art credentials. You may need to demonstrate you've been shown regularly in art galleries and museums, if you're work has been "collected," and if the subject work has been produced in limited numbers. You can't suddenly deem your own work "fine art" for the sole purpose of avoiding a lawsuit.

Your model release should also cover the entry of the image into a photo exhibit, competition, or contest. You'll find most if not all legitimate competitions require you to provide a model release on demand. And realize that only the people included in the picture can sign a release for themselves, with some exceptions like guardians signing for their children. So for a wedding photograph, neither the bride nor the groom, nor anyone else, can sign a release on behalf of Uncle Charlie or Aunt Sally.

## Family Feuds

Nobody fights like family. The ugliest, most hotly contested lawsuits concern divorces and wills. Ed has been professionally involved in the following scenario only about a dozen times. Same movie, same script; only the actors change.

A young hotshot male photographer shoots a young wannabe female model for "their portfolio." Relationship heats up; they move in together or even marry. His muse never signs any model release unless a paying client (few and far between in the early years) insists upon one. He cheats on her. She cheats on him. They fight, they break up, they reconcile, they divorce, and they split on less-than-amicable terms. One of those portfolio shots (sans release) turns up just when the model is looking for an excuse to break her ex's legs! The model has since become a big star (which she of course, attributes to leaving him). She strides into Ed's office saying she wants his head on a platter and, oh yeah, money would be good too.

LESSON: 50% of all marriages end in divorce. There are no reliable statistics on disgruntled former lovers, friends, stalkers, and so on. People and relationships change. Diamonds and model releases, however, are forever. A simple signed release would have saved the photographer tons of grief and, oh yeah, money too.

Simply put, in every circumstance you are never wrong and always better off having a signed model release in your pocket. Releases, like copyright registrations, are cheap, excellent, and essential forms of business insurance.

The rights of a person in his or her portrait, image, likeness, or even voice are commonly termed "rights of publicity" or "rights of privacy." These rights are independent of any of the photographer's intellectual property rights, such as copyright. Copyright is just a photographer's right to his images and how those images are shown and controlled. Subjects in your photos also have different and sometimes conflicting rights. In short, the person in your photo—whether a professional model or not—has rights too. Those rights may parallel those of the photographer or conflict with them. You may want to license an image to a particular client for particular purposes, but if the model does not grant the same rights by his or her consent, you cannot license your image for that purpose. The result being that you can't make a buck. You must strive to derive as many rights from the model/layperson as possible. Ideally both photographer and subject will find themselves on the same page, licensing identical rights to a paying client or customer.

Copyright does not give a photographer any rights to show an image without a model's consent. Want to put up wedding photos or a recent senior shoot on your website or blog? Well, you have to have a release to be properly protected. Depending on what state you're in, you may be sued and you may lose.

On pages 120-125 you'll find copies of model release forms you can customize and use in your daily business. While they differ slightly in form according to the type of shoot, use, or payment, they serve the key purpose of obtaining the model's written consent to use his or her image for limited or unlimited purposes.

It's easy to see why stock agents, ad agencies, models, and their agents and clients specifically require being provided with a copy of the model releases: they permit intended use and prevent lawsuits. Images without accompanying releases are generally worthless for most commercial usages, with the notable editorial/fine art exceptions. Concern about proper model releases applies to all sorts of photography and all sorts of clients.

## Retirement

You can just feel the heartbreak. A photographer with many clicks in a very long career is looking forward to retirement. The shooter receives a significant seven-figure offer for a small-but-notable portion of his collection to be employed in a sort of retro ad campaign by a new client. The photographer has not kept any of the model releases signed at the shoots—mistakenly assuming that since all of the shots were over ten years old, the statutes of limitations had long since run out. And the original client had thrown out all of its paperwork many years ago. No one knew or could recall the names of most of the models. The in-house people at the ad agency and in the photographer's studio who worked on the campaign 10+ years earlier had all long since scattered to the wind. All of the models were supplied by model agencies, some of which no longer exist.

When the perspective purchaser consulted its legal counsel on the value of these shots, the corporate counsel requested the releases. When told neither the releases nor models could be found, the attorney quite rightly killed the deal. The photographer was out seven figures and retirement is no longer on the horizon. The images now have value only as curiosities to be produced in photo magazines or perhaps a book (though even publishers are starting to require releases). No stock agency would touch them, nor would any advertiser. Their actual fair market value is now negligible.

LESSON: Never depend on anyone other than yourself to retain records. Not your agent, your lawyer, an ad agency, a model agency, and especially not the client. Keep model releases forever because businesses fold, people move, get fired, have poor memories, and even die. Dogs are dependable and reliable; people are not.

## Berne This!

The Berne Convention is neither a fireman's gathering nor a meeting of the George and Gracie fanclub. Rather, it was a political meeting in Berne, Switzerland in 1886 that spawned an international treaty governing how copyright laws are handled among nations. Prior to the treaty, literary and artistic works were not protected across national borders—a work created in the United Kingdom was protected by UK copyright laws, but could be freely copied and distributed in other countries. By creating several international standards of copyright law, the Berne Convention sought to resolve this dilemma and ensure equal application of copyright protection in all the signatory countries.

But for over 100 years, the United States refused to sign it. There existed at the time a fundamental difference of opinion on copyright law between Berne Convention signatories and the Unites States—namely, the United States did not recognize any copyright protection until the work was registered. You had to actively file with the Copyright Office in order to be protected. You also had to have a copyright notice appear on your photograph, or else your copyright would be invalidated and your work could fall into the public domain.

Rewriting these core principles of U.S. Copyright law took some time. By 1978, copyright was automatic and registration was voluntary rather than mandatory. With the Berne Convention Implementation Act of 1988, the United States became an official signatory to the Berne Convention treaty. With this Act (which came into force on March 1st, 1989), the necessity of having a copyright notice appear on your work in order to be protected under US Copyright law was eliminated. Of course, make sure you read our chapter on registration, because as we thoroughly explain there, copyright without registration in the U.S. severely limits your legal options in the event of infringement.

# HOW TO AVOID YOUR WORST NIGHTMARE

**1.** Use a written model release all the time; get it signed. You'll sleep better.

**2.** Always get releases from everyone in the photo. Spouses, girlfriends, significant others, employees, friends, and relatives. Everyone.

**3.** Other than for the exceptions mentioned earlier, every image is potentially valuable, so every image containing a person must be accompanied by a model release. Don't fall into the trap of thinking that work is not valuable. You would be amazed at the number of average or so-so photos that have become extremely valuable because the person in the picture becomes famous or infamous, or because events change the context of the image. (See "Who knew?" on pages 48-49.)

**4.** Leave no blanks in a release and make sure it's dated. Also make sure you obtain suitable identification from the model.

**5.** Provide a copy of the release to the model and then retain the original, if possible. If your savvy client requires the original, retain at least a signed copy.

**6.** Keep your signed release forever. You must retain the release so it can be given to your children and grandchildren. If anyone, even your accountant, tells you that you can throw out old model releases after a certain period of time, ignore the advice. There have been cases where the photo was taken decades prior to the objectionable use.

**7.** If the subject in the photo is a minor, obtain a written representation and proof if possible that the adult signing on the child's behalf is legally authorized to do so. These days the odds are good that a child might be or become product of a divorce; a parent in such circumstances might not have the authority to sign on the child's behalf. That right might be held exclusively by the other parent.

**8.** Oral consent is usually not worth the paper it's written on. There is nothing better than a written release.

**9.** "But she looked 18." We love that one. Sounds as dumb in this context as it does in any other context. Ask to see a driver's license. Make a photocopy and attach it to the release. As you know, minors cannot sign releases, right? Well actually they can sign them, they're just worthless.

# Can't Fake Editorial Use

Usually because no one bothered to get a model release, some photographers (and even some clients) attempt to "create" an editorial use. This usually occurs after the model has notified the user by legal counsel that the image was used without their client's consent. At this point, like Houdini, the photographer, ad agency, and/or client tries to escape. They will claim that the ad was not really an ad, and so it really does not require a written model release. Amorphous terms such as "open letters," "public service announcements," or "issue advertising" are used to describe the ads in an effort to skirt the laws requiring model releases.

Under New York law, a message is for "advertising purposes" if it solicits patronage of a particular product or service. For example, if an advertisement explicitly solicits patronage of medical, residential, psychiatric, mental health, and addiction services for fees (and health insurance covered fees), the fact that it also serves a secondary public or beneficial purpose like advocating the treatment of drug addiction, is not relevant to the fact that the piece is still an advertisement requiring a written model release.

Sometimes the background facts concerning the creation of the ad are key. Say an ad agency licensed an image from a stock house for a fee, retouched that image, wrote advertising copy, prepared the advertisement, and had it inserted into countless publications and websites on be-

half of the agency's paying clients—all of whom manufactured drugs, sold testing equipment, or treated diabetics. A claim that the resulting ad is not an ad but rather a newsworthy "public service announcement" or "open letter" not requiring a model release, would fail. The primary purpose was to direct, steer, and cause viewers to pay money and/or attention to one or more of the advertisers for their commercial benefit. If someone seeing the ad was made curious enough to get tested and discovered he/she was a diabetic, that's great, but it's still a byproduct and not the primary purpose of the ad.

To get protection under the newsworthiness or editorial use exception to the need for a written release, the image must bear a "real relationship" to the subject matter of the editorial in which it is used. The story cannot be an advertisement in disguise. An advertisement, even if it may have some secondary newsworthy value, is still an advertisement within the meaning of the law. Otherwise one could argue that any pre-existing advertisement for any item can be termed "newsworthy" if it, for example, contains a celebrity, advertises a "green" product, an electric car, a cure for a disease, and so on. If the primary purpose of an ad is to drive dollars and attention to those whose livelihoods are dependent thereon, it does not qualify as exempt from the requirements of the New York law.

An ad may become "newsworthy" if litigation was commenced concerning its existence. Lets say that a sexually explicit billboard is put up in Times

Square for a clothing company or a charity seeking donations. The user's profit or not-for-profit status is irrelevant to the issue of what the ad's "primary purpose" is. Whether the image was for commercial and trade benefit as its primary purpose is the key for model release purposes. Can a newspaper run a photo on the public's attempt to remove the billboard without obtaining a model release from the person portrayed on the billboard? Sure. The newsworthy exception has a long and storied history and exists so that newspapers, magazines, and the like can cover the news and stories of genuine public interest. Can the model sue the clothing company or charity if the image was used on that billboard without a written model release? You betcha.

Most exceptions to the model release requirements of state laws are fairly obvious, in that an image accompanying a magazine piece or news story of public interest does not generally require a release. Misuse of an image in such a publication could still lead to a claim in libel. Such claims arise when the image is used to falsely portray someone without consent. So for example, a story on rampant heroin abuse by young mothers utilizes the image of an innocent public citizen/mom playing with her kids in the park. Without consent of the subject, if the photo falsely portrays the subject as a drug abuser, pedophile, etc., then the fact that it is used in a newsworthy article becomes largely irrelevant. Mom has herself a great lawsuit and her lawyer can start shopping for a new car.

A classic example of the more typical scenario is that of, *Arrington v. N.Y. Times Co.* That case involved an image of a young, African-American financial analyst in a business suit walking on a Manhattan street. The photo was utilized in an article in *The New York Times* entitled "The Black Middle Class: Making It." That image clearly bore a real relationship, in that the image was of an actual young African-American financial analyst, and the article was about exactly that demographic. Brooks Brothers would need a written release if it wanted to use that image to sell suits. *The New York Times* did not need a written release or the permission of the subject.

St. Patrick's Day parade patrons dressed in traditional Irish garb, drinking Budweiser beer, utilized in a news story about the last of the Irish immigrants—no release needed. Use of that same image by Budweiser without a release? Verboten. The key is simply whether the relationship between the news story and the alleged violative image is fairly obvious.

# Contracts & Invoices

# contract & invoices

Hard economic times in an industry that has always been very competitive make it vitally important to know how to handle and understand clients with excuses, clients that are bullies, and plainly, clients that are thieves. You especially have to understand them if you want to get paid, survive, and even—dare we say—thrive. A business problem may be easily solvable, very complex, or completely unsolvable. The difference between collecting your money without losing any sleep and losing all your money plus all your sleep, can be summarized in one, neat word: Paperwork. Your paperwork is both your first and last line of defense in the battleground of business. Yet, far too many photographers fear that, like Robert DiNiro's character in the movie Brazil, they will be overwhelmed by it all and die by drowning in paperwork.

# Handling the Paperwork

The brain is divided into two hemispheres: the right side, which is creative; and the left side, which is analytical. Artists tend to be right-brain dominant and accountants and lawyers are left-brain dominant. Jack = right, Ed = left. You get the idea. When running a business, you really need a blend of the two. The right brain creates the work and the left brain bills clients and collects your money. Just like gears perfectly meshed and working in tandem, artists need to have both their right and left brains working together.

Unfortunately, most artists suffer from what actor Strother Martin once described, in a slow Southern drawl, as a "failure to communicate." Many an artist has trouble getting the left, analytical side of their brain to really kick in when it comes to paperwork. This is very evident when it comes to dealing with invoices—the vehicle business uses to get money.

If this is really not your world, not your comfort zone, that's okay. Simple solution: Get help. Don't hesitate to consult someone with bookkeeping, accounting, or managerial experience. There's no shame in getting good professional assistance. The best businesspeople are those who know what they don't know, and do know when to ask for help.

The indispensible element of every business transaction of any kind is some form of paperwork. Every industry has its own forms—a lease, a mortgage, a contract of sale, a rental agreement for a car, or a simple receipt at your favorite diner. For photographers, invoices are actually very simple forms; they will indicate the services provided, licenses granted, and terms of payment. Remember, you never want to "sell" your work; you only want to "license" your work. The difference is like renting a car from Hertz as opposed to buying a car at a Ford dealer.

# Typical Scenario

A photographer comes to Ed's office saying his best client hasn't paid him in eight months, but they are promising him another big job soon. What should he do? Jack would say, that's not a "client," that's a deadbeat debtor who will put you out of business. Don't laugh. It's very common for photographers to carry such clients because they are scared of losing any work, even if that work puts them out of business. The threat of losing work from a non-paying "client" has always scared creative types.

But Ed, being a lawyer, deals with it all the time. He asks the photographer to send him all the paperwork. Ed receives a spreadsheet that shows how many days were worked, where the work took place, and what the fees and expenses were. That gives Ed a picture of what's been done and maybe a sense of what's owed. Ed's office now calls the photographer and asks for the invoices. The photographer answers, "That is the invoice—the spreadsheet." We kid you not.

A spreadsheet is not and never will be an invoice. Ed suddenly understands why this photographer never got paid, and also why he drives a Yugo. The client's accounting department never got an invoice to pay, just a confusing spreadsheet. Even if it wanted to pay, it had a perfect excuse not to. There was no name to make the checks payable to, nor could the bookkeeper easily figure out how much to pay.

If you want to facilitate payment of your invoice, you need to appreciate what your client's accounting department faces: hundreds of invoices every month including rent, floor cleaning, exterminators, payroll, printers, taxes, and even some photographers. Your invoice needs to be as clear and informative as possible.

On page 94 is an example of a simple invoice. Adjust and fine-tune it as you want, but please don't get too creative with it. Fight your creative urges when it comes to routine paperwork—save your creativity for the camera. This is not the time to let your right brain take over too much. Please utilize the services of your local attorney to customize it to conform to your state laws as well as approve any tweaks you want to add to the form.

# historical briefs -1998-

Like all laws, copyright is open to interpretation by a judge and jury—or worse, by a legislator looking for votes. Artists who think that owning and controlling their work is an enduring, God-given right are, in fact, quite wrong. The public good, the public domain, and the "Commons of the Mind" are what Congress and the courts have in mind when they play with copyright law. God-given? Hardly. Big business, lobbyists, and large campaign contributions have been known to affect politicians views on copyright.

For instance, in 1998, with the new millennium approaching, the multi-billion dollar Walt Disney Corporation found itself about to lose its copyright on Mickey Mouse (and many other protected works from the early 20th century). Not about to lose its lucrative hold on its beloved cartoons, Disney began a huge lobbying effort to change copyright legislation and extend its copyright. Congressman Sonny Bono was only too happy to oblige—himself an artist with a vested interest in maintaining his own copyrights for as long as possible. The resulting Sonny Bono Copyright Term Extension Act (aka the Mickey Mouse Act) extended copyright protection for the lifetime of the artist plus 70 years, or 95 years for corporate works for hire. Powerful persuaders were Sonny and the Mouse.

# INVOICE BASICS

## Copyright Zone Guys ①

26 East Whowantstoknow Lane
New York, NY 10000
Phone: 212.555.0190   Fax: 212.555.0191

INVOICE

| | |
|---|---|
| **DATE:** | December 32, 2012 ② |
| **INVOICE #** | 121232 |
| **PO:** | 42-67-18-HUTT |
| **FOR:** | *Copyright Brand Sunscreen Lotion Ad* |

**Bill To:**

③ Joseph Schmoe
Schmoe Schlarry & Shirley Intergalactical Media Group
222 Stooge Blvd.
Hollywood, CA 90001
Phone: 1.800.Goodluck

| DESCRIPTION | AMOUNT |
|---|---|
| ④ **CLIENT/JOB:**  Shirley Youkid Suntan Lotion <br> **DESCRIPTION:** Photograph of Jack and Ed holding up Copyright symbol <br> **USE:** Print ads & billboards south of the Andomedia Nebula and Utah only. <br> **PERIOD OF USE:** One year from 01/15/2012 terminating on 01/14/2013 | |
| **CHARGES** | |
| Fees: Creative fee for shooting and usage as stated above | $50,000.00 |
| Labor: Hair stylist for Jack's hair and beard | $1,000.00 |
|      Hair stylist for Ed ⑤ | $1.00 |
|      Assistant for pre-light, prep and shoot | $650.00 |
| Props: Foam rubber circle "C" symbol | |
| Materials: Seamless, tape, etc. | $100.00 |
| Digital Capture and processing | $750.00 |
| Four Lark books so we could suck up to the publisher | $36.99 |
| Catering: For us to pig out with crew | $847.29 |
| Misc: Any items or services in connection with this shoot not itemized above | $632.36 |
| Please make checks payable to: The Copyright Zone Guys, LLP     **TOTAL** | $     54,017.64 |

⑥     E.I.N #:  11-111112

TERMS: Full payment is due upon receipt of this invoice.Final billing reflects
actual, not estimated expenses, plus applicable taxes. All fees and charges on
this invoice are for the service(s) and/or licensing described above.
Fees for licensing of additional available rights will be quoted upon request. ⑦
Interest at the rate of 1.5% per month shall be due on all sums not paid within
30 days of this invoice.

by: _____  Date:_____  by: _____  Date:_____ ⑧
    The Copyright Zone Guys, LLP                      Client

**RIGHTS LICENSED ONLY UPON FULL PAYMENT OF TOTAL BILLING** ⑨

1. Make your header legible and understandable, including who you are, where you are, and how to get a hold of you. This is for the person in accounting who has life-and-death control over when you will get paid. No one in the accounting department cares that you're the next big thing with a camera. All they care about is: who are you, how much money you want and for what, and if they do have to pay you, how to get in touch with you if necessary—period. We can't say that enough. This is one of the big mistakes we see on invoices. We've seen unreadable logos instead of names and not even an address as to where to send the check. Skip the fancy logos, and keep it simple.

2. Always date your invoice, and always have a unique invoice number that you generate. Get a PO if at all possible and for goodness sake, always state what client you are shooting for—which quite often is not the ad agency that gave you the job.

3. Again, simple stuff. Who gets the bill? Who are you sending the bill to and what company is paying you. Should be easy, but many photographers mess this up by addressing it to just the art director they worked with rather than the ad agency. We put the appropriate person's phone number right on the invoice as a convenience, so we don't need to hunt it down when we have to call and ask "Where's my check?" It saves you lots of time.

4. This section is the most important part of the invoice (well, maybe after the total). This is basically the license you are granting. It explains who is getting the license and what the image is—exactly and specifically. Never be vague here and say only " For photographs" or "For photography." Always, always have a complete and understandable description of the photograph or photographs. The use should also clearly state how the photo is being used, in what media, what geographic area, and even what it may not be used for, like "no TV," "No billboards," and Jack's favorite, "NO third party usage." The period of use should also state the date usage starts and the date usage ends.

5. This details the itemized expenses—not just "A photo." We find the more information you can give the client, the clearer it is as to what they are paying for, and the more likely you'll get paid in a timely manner. On the invoice, it's usually broad categories and totals. For complicated or larger jobs, you should add an additional page or pages, showing a more detailed breakdown of what was spent.

6. If the clearly written and legible name at the top of your invoice is not whom the check should be made out to, then make sure you let them know how to write the check. If your logo says John Smith but the checks need to be made out to John Smith Photography, Inc., then say so. Accountants are not mind readers. The EIN (Employer Identification Number) is meant to save the accounting department the bother of hunting you down to ask for it. We find this saves a lot of time.

7. In nearly all states, commercial parties can set interest rates on unpaid sums at rates higher than those permitted in consumer transactions. If this rate is not written in your agreement, then you may be entitled to no more than the so-called "legal interest" rate in your state. Check with your local attorney to determine what the maximum rate your state's law allows.

8. This part is easy to explain. Make sure you sign your own invoice, and definitely make sure to get your client's signature.

9. This can be one of the most important lines in your invoice. If you are not paid, it states in clear bold letters that your client cannot use the images until you are paid in full.

## Numbering Invoices

Make sure you have a unique number on each invoice. It doesn't matter what that number is, as long as you have a number that doesn't repeat in your organizational system. Some people like to start with a three- or four-digit number like 100 or 1000, and then just continue numbering: 100, 101, 102, and so on. Other people like to use the date, but they sometimes mess up and use the common Month/Day/Year configuration. That's all well and good for the first year of business, but after that, you'll find your system totally out of chronological order because it's sorting by the month instead of the year.

So make sure you use the Year/Month/Day method instead. That way, an invoice written on the 4th of July, 2010 will have an invoice number of 20100704. Note the double digits for the month and day, even if it's a single-digit month. January through September should be 01 through 09, as should the first nine days of each month. You can also drop the year down to two digits, unless you think your business will last until the next millennium. That way, the 12th of December, 2012 will read 121212. We just love those dates.

## LICENSE TERMS AND EXPLANATIONS

There are other important things that must be in your invoice. Remember that your invoice will serve as the license for your work. You need to clearly spell out the use for which you are licensing the images, and for what period of time. "What for" can be broad or specific, but in either case the wording needs to be clear. When Jack licenses a broad usage, like PR (Public Relations) use, he will also list what is NOT included: no billboard, no TV, and so on.

The terms and explanation can be quite simple with some jobs; with others, it can be more complicated:

Simple #1: Consumer magazines (only) commencing on 1/1/11 terminating on 1/1/12

Simple #2: *Newsweek* magazine, 1/1/11 issue, North East Regional insertion only

Complex #1: North American Consumer Magazines of not more than 1 million paid circulation only

The period of use (aka the license term) must also be clear. If it's a fixed time, when does it start? When does it terminate? For exactly how long? Two months, one year, no time limit?

And what other restrictions? Geographical limitations, if any, are also important. "North America," "New York State only," "Milwaukee only," "East of the Mississippi only," "Worldwide," or even "Intergalactic." Whatever has been negotiated must be written. The more usage for the client, the more you should be charging.

For business portraits you might want to include the line, "No third party usage." This means that if that Acme Company banker or real estate broker whom you photographed quits or gets fired, they can't take your photo and use it if they get hired by a competitor of the Acme Company or any other company, even in a different field. Your license is restricted for PR usage by the Acme Company only.

Then there is one line that you have to include. *This is a must.* You must, must, must include the line: "Rights licensed only upon full payment of total billing." That single line, coupled with the retention of your copyright, can make all the differ-ence in whether or not you get paid. Your client's failure to pay you may now constitute copyright infringement. (Read Chapter 2 to understand fully what this means.) If your client seeks protection under the Bankruptcy law, that line will make a huge difference in making sure you are at the front of the line when the Bankruptcy Judge looks at who will be paid.

Also, remember to fill in ALL the blanks of any invoice, model release, or other paperwork you use. Do not leave anything blank. If there is a blank where a name or product name should be, fill in that name. If there is a blank for a date, don't do it later, fill it in now.

# When Clients Go Bankrupt

Photographers get scared and panic when they hear that their client is "going bankrupt." Often you might see press reports to the effect that the company filing for bankruptcy protection plans to sell its assets, which may include photographic images or illustrations created by you that have been incorporated into product packaging and/or sales materials. Do not assume that merely because a company seeks protection under the Bankruptcy Law that you are without a remedy and will "never see a dime." If your paperwork, your invoice, and your registrations are in order, then you have plenty of power and options in bankruptcy court.

A "sale" of your imagery to a new entity, or to a vulture company picking off the assets of a closing company, cannot take place without your participation unless you elect to do nothing. However, time is of the essence and you must act quickly. Sloth will get you screwed. Your rights will likely be ignored if you do not exercise them within certain time periods set forth by law. You will receive notices of these deadlines from a bankruptcy court itself, a bankruptcy trustee, the company filing for protection, and/or a law firm.

As a licensor of copyrighted material, you have more rights than most creditors trying to collect. In fact, if your work is registered, you leap frog over most (not all) creditors on the collection line when it comes to getting paid outstanding royalties or fees. You get special treatment because of your status as a copyright holder with a registered copyright. Conceivably you can recover money for copyright infringement while all other creditors (save the government and employees) recover zilch.

On top of collecting money, you as creator and copyright holder can still grant a new license, deciding who can use your work, and for what purposes. A bankruptcy judge cannot alter that existing license without your consent. The Bankruptcy Court or a Bankruptcy Trustee routinely obtains such consent by paying money to the creator. That kills the "never see a dime" cliché.

The Bankruptcy Act is a Federal Law. The Copyright Act is a Federal Law. In the eyes of the federal courts, they are equal to the other. A bankruptcy court does not have the power to overrule the copyright law. If you find yourself dealing with a bankrupt client, consult with an attorney knowledgeable in bankruptcy law. Most attorneys do not practice in this field and therefore know nothing about the land where intellectual property rights and bankruptcy rights collide.

If you have an agent or rep, you should do all the paperwork and the checks should be made out to you, the copyright holder. Provide a photocopy of the check to your agent/rep when you get paid. If for some reason you don't prepare the invoice (though we highly recommend that you do it) then make sure you get a photocopy of the invoice and, most importantly, a photocopy of the check. A key element here is that you, the photographer, are the creditor—the one due the money—not your agent.

Jack had one high-profile photographer friend complain about how slow the ad agencies were to pay, but he had a good rep (agent) who always rattled the trees and got him a check when he really needed it. Jack asked the photographer, "How long does it take to get paid usually?"

-Six to eight months.
"Who bills?"

-The rep.
"Who gets the checks?"

-The rep.
"Do you see a copy of the check?"

-No.
"OK," Jack said, "next time, ask to see a copy of the check from the ad agency as a check and balance system." Jack knew the answer to all this. Skipping the gory details and excuses from the rep, suffice it to say the photographer and rep no longer do business together.

Despite what reps want photographers to believe, the rep works for the photographer—not the other way around. Photographers should always have the check sent to themselves and then pay the agent, not vice versa. Not doing that opens up a snake pit of potential problems. If the check goes to the agent/rep, then the photographer has to wait for that check to clear the agent/rep's bank account and then wait again for it to clear their own bank account.

## Words Matter

Use of the word "agent" is important in any contract where someone is representing you, your reputation, and your work. There have been and continue to be major efforts by both representatives and stock agents to retire the use of the word "agent." Creator beware! Why? What's the difference between an "agent" and any other term?

An agent has specific legal obligations and responsibilities imposed by law. That may not be the case with independent sales representatives, distributors, or any other entity. Non-agents can sell any product they want to, without any obligation or allegiance to one particular brand. They may even give away products or services, and favor one supplier over another. Not so for agents. By law, an agent has a fiduciary responsibility to act in and protect the best interests of their principal: You. You're their boss. With their authority to sign a contract on your behalf or collect monies due to you comes their legal responsibility to always serve the interests of no one but you.

As a result of these more stringent obligations, some individuals or agencies go to comical lengths to avoid any hint of having the responsibilities of an agent. Some stock agencies employ contracts where, even though they describe and promote themselves as "agents," "agencies," or "agents for content," additional legalese is purposefully inserted stating that the stock agency is not an "agent" as defined by law. They may also use the terms "distributors" or "sales representatives." These faux agents may have no motivation to pursue infringements of your copyright—often because they don't want to alienate another of their own clients. And if, buried in the fine print of your contract, you've signed away your rights to pursue infringers to them and them alone, you may be left without recourse. If you did try to pursue the matter, you might need to pay the agency in order to regain your permission to pursue infringement claims, which you have foolishly given away.

Ed has drafted contracts that contain clauses permitting joint copyright infringement pursuits at the photographer's option. These clauses incentivize each side to pursue infringements or assist the photographer in the event the agency is disinterested. If the agency wants to opt out so as not to antagonize a client, no problem—the photographer will receive all of the recovery, but will need to front the costs on their own. In such cases, you still want the agency to agree to supply cooperation, testimony, and documents supporting your claim at no cost to you.

The use of the word "photographer" also matters a great deal. Many stock agencies prefer the term "contributor" or "content provider," rather than "photographer." By using these terms, all creators can be deemed "fungible"–i.e., all the same, none more valuable than the other. This promotes the notion that images make money just like any other commodity, e.g.: a plumber's weld is no different than a photographer's image. But—as discussed on page 25—that ignores the important concepts of intellectual property and copyright protection. If agencies respected the work of their contributors, then they would call them "photographers." When you fill out your 1040 form, do you put down "contributor" for your occupation? Why the fuss over mere semantics? Because words matter.

# PRICING: THE BLACK ART OF PHOTOGRAPHY

The hardest part of being a professional photographer isn't taking a photograph, or deciding which lens to use, how to light, what directions to give the subject, or what props to pick. Nope. The hardest part is figuring out what to charge. There is no set answer, because there are so many factors to weigh in pricing your photography. Your overhead and experience may be two big factors; how difficult the job is to photograph is usually a pretty small factor. Talent, not technical expertise, will always win out. So how do you put a price on your talent?

## PRICING COMMERCIAL ASSIGNMENTS

Commercial photography is a business-to-business affair, unlike the retail transaction of a wedding or portrait studio. In those cases, the general public can come in and look at a price list; they are buying known quantities for personal use. What matters in commercial photography is determining the appropriate license for an image, based on the client's usage and period of use. Placing an image in a national consumer magazine like *Time* is very different than running it in a half-page ad for a trade magazine like *Supermarkets Today*. The same photograph can cost either $500 or $5,000, depending on the usage.

For example, late into the last century, Jack licensed an image to a small-circulation trade magazine for $500. It was a fair price for that usage, at that time. A few weeks went by, and Jack got a call from someone's assistant at a major TV network. Someone had seen Jack's photo from the trade magazine, and decided they absolutely had to have it for an ad that was on a tight deadline. Jack was offered $2,000 on the spot—for the same photo that earned a mere $500 only weeks earlier. You'd think that Jack would have jumped on this higher price, right? Not so fast. This is where it gets interesting, and complicated.

"What's the usage?" Jack asked.

"In *TV Guide*!" the assistant proudly replied.

Jack's ears perked up, as *TV Guide* is one of the highest-circulation magazines in the country, meaning they charge more money per ad space than most any other magazine. After a couple follow-up questions, Jack figured that the TV network was probably paying a six-figure sum for the ad space. At that point, Jack said "No" to the $2,000 offer. Clearly, there was a large enough budget for this ad that Jack deserved a higher price. He quoted $5,000 dollars for the usage.

"But the most we ever paid anyone is $2,500!" exclaimed the excitable assistant.

Suddenly there was more money in the pot that wasn't there before—as is often the case. Nevertheless, the fact that other photographers had settled too low wasn't Jack's problem. There's a lesson here: Don't fall into the trap of a "take-it-or-leave-it" offer. Be willing to walk away and mean it. Jack wouldn't have been able to look himself in the mirror, knowing he had undersold himself when they were already spending hundreds of thousands of dollars just for the ad space. Trust us, you'll never feel terrible about walking away from a bad deal. You might feel bad, but never terrible. And sometimes you even feel downright exuberant to have held your ground.

But it doesn't end there. About a month later, someone else called asking to license the same image for another national ad. Jack quoted his $5,000, and the client accepted. Done deal. Now understand that if Jack had taken the original $2,500 deal, he wouldn't have been able to relicense it again during that same period to someone else. For one thing, it's just not ethical; but more importantly, it would have seriously risked Jack's reputation. You really don't want the same image in two national magazines for two different products at the same time (don't laugh— it's happened many a time).

So $500 was a fair price, then $2,500 wasn't fair, and then $5,000 was fair, all for the same image. Makes your head spin, doesn't it? You have to know your value in the marketplace. You also have to be flexible, of course, but always know what is your floor— what is the price you need to make a living?

## Helpful Hints

## Dead Celebrities

How big is licensing? Well, licensing the rights to dead celebrities—"delebs" in the trade—is almost a billion-dollar-a-year industry. And that's the dead ones like John Wayne, James Dean, Marilyn Monroe, Elvis, and Albert Einstein. OK, Elvis I get, but Albert Einstein? Yes, they trademarked him and if you want to use Einstein commercially, you need to license it. The army of lawyers looking after the intellectual property which includes the "right of publicity" of these dead celebrities are very aggressive in protecting those rights. Licensing for the rights to use these images or likenesses are, in most cases, earning even more than these people made during their living and breathing days. Can you say, "happy estates?"

# COMPARATIVE AND COMPETITIVE BIDDING

The previous story concerned an image that Jack had already taken, but plenty of other jobs start when an art buyer or art director calls you with an assignment. In this case, the first thing you want to find out is whether it is a competitive bid or a comparative bid. A competitive bid is just that—the client has competing photographers estimate and bid for the job, based on provided layout and specs. Like jobs for the federal government, the lowest bid usually gets the job.

A comparative big is different, in that the lowest estimate may not get the job. Art directors may use a comparative bid to see what a project will cost, or to see how different photographers will approach the same project. You should always provide a good, realistic estimate in such cases, mainly because you never know what they're looking for.

## NEGOTIATION CHECKLIST

When an art director calls you for a job—whoopee! First and foremost, before you get too excited about the project, get that person's name and phone number. Have them spell their name if you're not sure. Then get the names of the agency, design firm, company, whatever.

Next, find out how they found you. Your promos? An ad in a photographer's catalog? Your website? A recommendation from another art director? That is valuable information as to what is working well for you. At this point, don't try to sell yourself even more, as photographers tend to do. Just listen and try to figure out what they really want. Pay attention. Ask them about the shot they have in mind. How do they see the image? Can they send you a JPEG or PDF of the ad? Are you the only photographer they're talking to or is this a competitive bid? A comparative bid? What is their schedule? Is there a specific deadline? Clarify as much as you can, but don't say anything definite concerning your idea for the shot until you get a "whole picture" of what's involved.

Then, of course, you have to find out the specific usage. Without that you can't give an estimate of what you will charge. Trade ad or national ad? North America or Worldwide? Billboards, POS (point of sale), or brochures? And also how long? Six months? Two years? Unlimited?

If you can get them to give you a price upfront, all the better. Sometimes that can become a game of Go Fish, where the first person to say a price loses…

"What's the budget you have in mind?"

"Well, we don't know. What do you think it will cost?"

"What kind of production values are you looking for? Big production with lots of props, or something simpler?"

"Well, do you have a ballpark for the high end and the low end?"

"Well, we can do it several ways. But before we make the calls to models, model makers, hair, and makeup, we can get more accurate numbers for you to pass on to your client if we know the scope. We wouldn't want to find pit falls later and have to raise the price."

You get the idea. The last sentence is especially good, as it puts the onus on the art director to give you an idea as to what they want. Since Jack photographs people—usually models—he likes to shift the discussion to the fact that he can't get the model prices for the estimate until he gets the exact usage, as that will directly affect the model pricing. Whatever you do, never give a ballpark number. In fact, you shouldn't quote any price right away. The best thing to do is hang up the phone and really give it some thought—even if they gave you a price upfront. $100,000 might sound fantastic at first, but if you crunch the numbers and find out that it would cost $98,000 to produce, then you might be better of flipping hamburgers for the amount of time and work involved. Besides, they hardly ever give you the real budget at first. Who would? If you can meet their initial budget, great; but if not, be truthful with your numbers. You'd be amazed at how often they can find the extra money.

Another reason to carefully think out a project is that it's not always just the bottom line, but rather how you present your estimate. Compare these two estimates:

## Photographer "A"

**Fee = $15,000**

**Expenses = $60,000**

**Total = $75,000**

## Photographer "B"

**Fee = $15,000**

**Producer = $6,000**

**Digital charges = $2,500**

**Equipment rental = $8,250**

**Hair and makeup = $2,400**

**Model maker to make special prop = $9,525**

**Baby wrangler = $1,250**

**Stylist = $5,500**

**Props = $800**

**Wardrobe = $1,500**

**Assistants for lighting = $800**

**Assistants on set = $2,400**

**Transportation and shipping = $3,500**

**Catering = $1,250**

**Models (billed direct to agency) = $22,450**

**(And so on and so on. You get the idea)**

**Total = $83,125**

Now, if you were an art director and had to decide between these two estimates, and your own job depended on you making sensible, secure decisions for your clients, which photographer would you feel more comfortable with and confident in? In order to protect your job and provide the client with a good product, you'll be more inclined to go with the more detailed estimate because it shows where the money is going and what the photographer is thinking.

## Helpful Hints

## Social Networks

To Facebook, Tweet, chat, or blog? That is the question. No matter which you choose, the answer remains: Proceed with extreme caution.

Never post your complaints about jobs or business situations to the Internet. Clients do have ears and eyes, and can be extra touchy. There is no such thing as privacy on the Internet—even on a private, password-access site. If you can type it, it can be copied and passed around. Once posted, that information is out there, and trying to get it back is like trying to stuff toothpaste back into the tube. Ain't gonna happen. There are tons of stories about "private" conversations becoming viral, or just being passed on to the wrong person. If you aren't willing to shout it on a soapbox, with a megaphone on Main Street at noon, then don't type it out on a keyboard. What you might say on Main St with a megaphone is actually less damaging than anything you say in a chat room or in a blog. That stuff on the Internet is forever. Even after you take it down, it can still exist somewhere.

Comments made on the Internet are not confidential and are routinely discoverable in litigation. That means that you and/or the website can be forced to provide copies of your posts in pre-trial document production by the courts. There is no dance or excuse to avoid this. And if you try claiming First Amendment rights, you will just give the court a chuckle or maybe even a good laugh. This also means that anyone who has seen or read the post can willingly testify and/or turn over copies of the posts to the lawyers; or, if necessary, any such person can be forced via subpoena to produce the posts and/or testify as to what they contained. Recently, an increasing number of people have been sued for libel, product or trade disparagement, etc. because of statements they posted online. Why run the risk of making your bank account disappear and the lawyers rich?

# Social Networks Continued

Generally, the conversations listed below are confidential and privileged by state law. There are some states that specifically grant additional confidential privileges to discussions with therapists, counselors, and so on. Some conversations are privileged only because a specific court order may make them so.

• Spouses speaking to each other within the confines of marriage

• Statements and conversations including, but not limited to, formal confession, between a "real" Rabbi, Priest, Imam, Minister, etc. and a layperson who is confiding in such a clergyman

• Conversations between an attorney and a client (even if the lawyer has not been formally retained)

• Conversations between a doctor and a patient

• A formal written contract—such as a CIA contract with an operative—and confidentiality agreements

There are simply no laws that render posts in chat rooms confidential. We can't emphasize that enough. To illustrate, here's a common scenario: A photographer seeks pricing guidance on chat board. The post typically reads something like the following:

"I did a job for the XYZ Shoe Company. The usage was for in-store/point-of-purchase only, in their 10 company-owned stores, for one year. The job went well and I got paid. About a month later they called me and requested additional usage in non-company-owned stores that will now be selling XYZ shoes, and/or they now want to extend the original usage to 5 years. I want to charge $X,XXX for the new license, but am afraid that price is too high and they won't go for it (or that price is too low and I deserve more). What should I charge and how should I handle this? I don't want to alienate the client because I want more work from them, but I need the money real bad as business has been very slow. Any suggestions on how I should proceed?"

Since it's rarely a good negotiating tactic to tell the other side how much money you really want—much less that you desperately need their money or their business—this poster unintentionally did the next worst thing. They made it public. So after receiving many well-intentioned suggestions from fellow shooters, the photographer approached the client with their refined strategy all planned out.

As Gomer Pyle used to say, "Surprise, surprise, surprise!" XYZ Shoes knew exactly what the shooter was going to ask for—as they too had a computer hooked up to the Internet. When contacted, they promptly offered the photographer half of what he was asking, on a take-it-or-leave-it basis. They further advised the photographer that if the offer were not acceptable, they would do a new shoot with another photographer. By posting his pricing question on the Internet, the photographer was handing over his playbook on a silver platter. These posts are not secret, confidential, or privileged—nor is readership confined to altruistic fellow photographers.

## A GREAT PHONE CALL

One of Jack's best assignments in recent years was a bid for a pharmaceutical ad of kids. His agent found out later that, initially, the client had had a "choice" photographer already picked and Jack was the second choice. But Jack ended up getting the job. How? A five-minute phone call.

Jack called the art director, as he usually does, to speak creatively about the job. The art director was a simple and quiet person, and let Jack go on and on about how he envisioned images for the ad. "Bright images, well lit, but still with a direction to the light. A simple set, not seamless paper. Yadda, yadda yadda." The art director didn't say much, and at first Jack figured he hadn't connected with him and didn't expect to get the job.

However, it turns out that when the "choice" photographer called the art director, he basically said, "So…what do you want?" He didn't have a vision to share, and he didn't make the art director confident at all. So Jack ended up getting the job, even though price didn't come into play at all. What mattered was the Jack had real input and a better idea of how to produce the job.

---

**Helpful Hints**

## Pricing Software

Faced with the challenging and confusing array of pricing elements, how does a photographer determine a licensing fee that is a win/win for both parties in the negotiation?

Today we have software. FotoQuote is the most extensive and comprehensive pricing software available. Their prices are also based on feedback from photographers actively using their program, so it's kept up-to-date and realistic in today's marketplace. FotoQuote give you a range of prices for a particular usage, and also considers production value, signed model releases, and other factors. This can be especially helpful when an art director calls you for the 12th time, requesting a new estimate based on new circumstances or a new usage request.

Warning! Do not be a prisoner to the so-called pricing boundaries set by any pricing software. What you charge is ultimately determined by you and you alone. As many of Ed's clients—including Jack—often do, you may even elect to distinguish yourself from your competitors by charging more than they do. Remember, many clients equate price with quality. High price = High quality. Low price, well you get the idea. Logical or not, it's real life.

# RETAIL PRICING

So far we've talked about pricing for only commercial work—basically business-to-business situations. There also exists a vast universe of "retail" photography, or as it's aptly called in Europe, "social photography." This encompasses weddings, portraits, school graduations, sports teams, and anything else wherein a photographer is selling (whoops) licensing their work to the public.

The best pricing information for this type of work, by far, is through Professional Photographers of America (PPA). They are the largest photographer trade association in the world, with over 25,000 members, and they have a benchmark survey that they have compiled over many years and continually update. This survey is only available to PPA members, and if you're a professional photographer working in the arena of retail photography, it makes a lot of sense to join—not just for the survey, but also to be covered with their unique indemnity insurance.

PPA's website (www.ppa.com) explains the benchmark survey as follows:

"By definition, a benchmark is 'a standard by which something can be measured or judged.' Professional Photographers of America's Benchmark Survey is a financial snapshot of the photography industry. Its findings will allow studio owners to compare their financial operations to other studios of similar sales level or years in business as well as assess their productivity against overall industry averages and 'best-performance' studios. It also validates the industry standards for financial management and accounting."

The PPA Benchmark Survey is also geographical, so you are comparing New York apples to New York apples and California oranges to California oranges. This is great, as retail pricing can be extremely region-sensitive. Their pricing survey can even bore down to individual cities, not just large state areas.

PPA is also good at making sure you know what business licenses you need, what taxes you need to pay, and various other financial considerations. When you have a retail photo business, it's vital that you learn how to evaluate all your true costs. Too many photographers jump into this type of work, assuming that what they charge for their photography is what they make. "Wow, a thousand dollars for photographing a wedding on the weekend! That's more than I make at my 'real' 40-hour-a-week job!" Thinking that all that money goes directly into your pocket will get you an express ticket to the poor house. PPA's great instructors, like the fabulous Ann Monteith, are excellent at pointing out that you have to take into account all sorts of hidden and true costs.

You may quickly discover that the 6-hour wedding shoot is just the tip of your time involvement. There is also the time spent working out a shot list with the bride, prepping your equipment, getting to and from the event, editing (where many photographers find out just how few hours there are in a day), meeting with the bride again, designing and laying out the wedding book, dealing with the printer, and so on. And that's not to mention the task of dealing with a "Bridezilla." Even normal, well-adjusted, good-humored brides will still take up a lot of your time. Having a Bridezilla on your case is like spending time in another dimension.

So, pricing retail photography—or any photography, for that matter—is not just about coming up with a price that sounds good. You have to evaluate your true overhead expenses, capital expenses, general expenses, and cost of sales; and you also need to decide whether you are doing cost-based, competitive-based, or demand-based pricing of your photography. Some of that will depend on where your studio is located—in a storefront or out of your home? What are the buying patterns in your community? Some parts of the country have a rich tradition of having an annual family portrait done with very large prints, and in some areas a family portrait is a rare occurrence. Wedding traditions in one part of the country are strange customs in another. If you want to have long-term success in a retail-type business, you need as much information on your clientele as possible.

Getting that information from a non-profit trade association like PPA, whose entire purpose is to help their members, is a great start for any photographer. There are also a bunch of for-profit photographer organizations in the retail photography world. We would advise you to be careful when dealing with these, as they are mainly interested in making a profit *from* their members and not as much *for* their members.

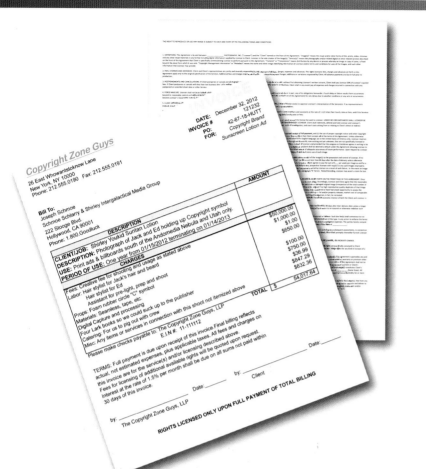

## TERMS & CONDITIONS

As there are two sides to every story and two sides to every coin, so there are always two sides to every invoice. The back of the invoice, contained on that one page—in very small type if need be—is what is known as the terms and conditions (T&C). Those are your terms and your conditions. Anybody who sells you something has their own terms. It could be your local diner that says, "No shirt, no shoes, no service" or "No checks or credit cards." Those are the diner's terms and conditions. When you buy software, you are not actually buying it, but rather being issued a license. Opening the package seal or clicking on "Agreed" when you download the software is binding you to the software maker's terms and conditions.

So why wouldn't you as a photographer have terms and conditions of your own? You're the one providing the service, and like any other business, you provide the paperwork. Below is an annotated T&C that you can use as a basis for your own T&C.

# THE RIGHT TO REPRODUCE OR USE ANY IMAGE IS SUBJECT TO EACH AND EVERY OF THE FOLLOWING TERMS AND CONDITIONS

1. DEFINITIONS: This Agreement is by and between _____ PHOTOGRAPHY, INC. ("Licensor") and the "Client" named on the front of this Agreement. "Image(s)" means the visual and/or other forms of film, prints, slides, chromes and any other visual materials in any format including digital information supplied by Licensor to Client. Licensor is the sole creator of the Image(s). "Service(s)" means the photography and/or related digital or other related services described on the front of this Agreement that Client is specifically commissioning Licensor to perform pursuant to this Agreement. "Transmit" or "Transmission" means distribution by any device or process whereby an Image or copy of same, is fixed beyond the place from which it was sent. "Copyright Management Information" or "Metadata" means the name and other image identifying information of Licensor and/or terms and conditions for uses of the Images, and such other information that Licensor may provide.

*Defining terms in an agreement between the parties helps to eliminate any claims of misunderstanding or "I didn't think you meant XYZ I thought you meant ABC." The agreement is, as they say in Court, "dispositive." If the parties have agreed in writing as to what means what, the Court will not seek to re-interpret or change those mutually agreed upon definitions if the contract is clear and readable—dictionary definitions not withstanding.*

2. FEES, CHARGES AND ADVANCES: Client and Client's representatives are jointly and severally responsible for full payment of all fees, charges, expenses and advances. The rights licensed, fees, charges and advances set forth in this Agreement apply only to the original specification of the Services. Additional fees and charges shall be paid by Client for any subsequent changes, additions or variations requested by Client. All advance payments are due in full prior to production.

*The client has agreed to make full payment. This clause acknowledges that the license granted is only as stated in the agreement.*

3. POSTPONEMENTS AND CANCELLATIONS: If Client postpones or cancels any photography "shoot date" or other Service, in whole or in part, without first obtaining Licensor's written consent, Client shall pay Licensor 50% of Licensor's quoted fees. If Client postpones or cancels with less than two business days' prior written notice to Licensor, Client shall pay 100% of Licensor's quoted fees. Client shall in any event pay all expenses and charges incurred in connection with any postponed or cancelled shoot date or other Service.

*This clause ensures that a client who decides at the last minute to "go in another direction" (by hiring someone cheaper than you) would still be on the hook to pay you. The onus for the cancellation is on the client, who must pay for your inconvenience and time. Also see Force Majeure, below.*

4. FORCE MAJEURE: Licensor shall not be in default of this Agreement by reason of its delay in the performance of or failure to perform, in whole or in part, any of its obligations hereunder, if such delay or failure results from occurrences beyond its reasonable control and without its fault or negligence. Client will pay 100% of Licensor's daily weather delay fee (as set forth on the front of this Agreement) for any delays due to weather conditions or any acts or occurrences beyond Licensor's reasonable control, plus all charges incurred.

*Without clauses like 3 and 4, you would not be entitled to any cancellation or kill fees without a lawsuit, if at all. This paragraph is extremely important if you are shooting on location or affected by factors outside of your control—the weather, client's employees, airline cancellations, or events postponed by the performer.*

5. CLIENT APPROVAL: Client is responsible for having its authorized representative present during all "shooting" and other appropriate phases of the Service(s) to approve Licensor's interpretation of the Service(s). If no representative is present, Licensor's interpretation shall be deemed as "accepted." Client shall be bound by all approvals and job changes made by Client's representatives.

*The client may haves an authorized person present during the shoot to approve imagery; or if it elects not to have such a person present, your imagery gets emailed to the client **while the shoot is taking place**. In either scenario you want the client to indicate its approval of images by initialing or signing copies of the images or emails referencing the imagery. This eliminates the possibility of a client making a claim (asserted to avoid payment) that the images "missed the concept entirely" or "are not what we wanted." This clause protects you in the event you are unable to transmit images to a client who has no representative present.*

6. OVERTIME: In the event any Services extend beyond eight consecutive hours in one day, Client agrees to and shall timely pay overtime for crew members and assistants at the rate of 1-1/2 times their hourly rates or fees, and if the Services extend beyond 12 hours in one day, Client agrees to and shall pay overtime for crew members and assistants at the rate of double their regularly hourly rates or fees.

*Without this clause you are not entitled to any such payments from your client. State labor laws may vary, but your assistant conceivably could have a claim against you for overtime pay. This covers crew members only. If you as the photographer are seeking overtime compensation, you must specifically include your terms in the agreement.*

7. LIMITATION OF LIABILITY AND INDEMNITY: Even if Client's exclusive remedy fails of its essential purpose, Licensor's entire liability shall in no event exceed the license fee paid to Licensor. UNDER NO CIRCUMSTANCES SHALL LICENSOR BE LIABLE FOR GENERAL, CONSEQUENTIAL, INCIDENTAL OR SPECIAL DAMAGES ARISING FROM THIS AGREEMENT, THE IMAGE(S) OR ANY ACTS OR OMISSIONS OF LICENSOR. Client shall indemnify, defend and hold Licensor and Licensor's representatives harmless from any and all claims, liabilities, damages, and expenses of any nature whatsoever, including actual attorneys' fees, costs of investigation, and court costs arising from or relating to Client's direct or indirect distribution, display or other use of any Image.

*You as the Licensor are limiting the nature of the financial damages for which you could be held liable. When a contract is breached, the recognized remedy for an owner is recovery of damages that result directly from the breach, such as the cost to complete the work in accordance with the contract, the value of the lost or damaged work, etc. Consequential damages (also sometimes referred to as indirect or "special" damages) include things like loss of profit or revenue. These type damages could mean instant bankruptcy for a creator. The cost to re-shoot a tabletop shot pales in comparison to the loss of operating revenue or profits that a client may claim and even prove resulted from your error. In short, you can't afford to be on the hook. This clause demonstrates the client has agreed not to put you on that hook.*

8. RIGHTS LICENSED: The licensed rights are transferred only upon: (a) Client's acceptance of all terms contained in this Agreement, (b) Licensor's **actual receipt of full payment,** and (c) the use of proper copyright notice and other Copyright Management Information requested or used by Licensor in connection with the Image(s). Licensor is willing to license the Image(s) to Client only upon the condition that Client accepts **all** of the terms of this Agreement. Unless otherwise specifically stated on the front of this Agreement, all licenses are non-exclusive; the duration of any license

is one year from the date of Licensor's invoice and is for English language use in the United States of America only. Licensor reserves all rights in the Image(s) of every kind and nature, including, without limitation, copyright, electronic publishing and use rights, in any and all media, throughout the world, now existing and yet unknown, that are not specifically licensed or transferred by this Agreement. No license is valid unless signed by Licensor. This Agreement may not be assigned or transferred without the prior written consent of Licensor and provided that the assignee or transferee agrees in writing to be bound by all of the terms, conditions, and obligations of this Agreement. Any voluntary assignment or assignments by operation of law of any rights or obligations of Client shall be deemed a default under this Agreement allowing Licensor to exercise all remedies including, without limitation, terminating this Agreement, the right to all net worth or financial information of any assignee and the fullest extent of adequate assurances of future performance. Upon request by Licensor Client shall provide Licensor with a full and complete disclosure of any and all uses of each Image and provide Licensor with three (3) copies, without charge, of each and every use of each Image.

*This critical clause states that you are licensing that which the agreement specifically sets forth ONLY. If your client wants an "exclusive" it must pay for it, and your agreement should state this. If your client wants packaging rights, the agreement MUST say "packaging" and you may charge accordingly. This reinforces your right to get paid in full, prior to the client using the images.*

*The last sentence assures you that copies of any and all uses (authorized or not) will be available to you. If the client is suddenly unable to produce copies of unauthorized uses, this sentence enables a court to in effect give your testimony heightened credibility and, in some situations, the ability to penalize the non-paying or infringing client. Note the simple sentence in the clause that reads, "No license is valid unless signed by Licensor." So make sure you sign your invoices. We urge you not to edit this clause without the assistance of an attorney. Leave it just the way it is.*

**Note:** *If you shoot or ever deliver analog images, include paragraphs 9 and 10 below. See comment below paragraph 7. If all your work is digital and you never, ever deal with analog images you can omit both paragraphs.*

9. RETURN OF ANALOG IMAGE(S): Client assumes all risk for all Image(s) supplied by Licensor to Client, from the time of Client's receipt, to the time of the safe return receipt of the Image(s) to the possession and control of Licensor. If no return date appears on the front of this Agreement or on any related delivery memo, Client shall return all Image(s) in undamaged, unaltered and unretouched condition not later than 90 days after the date of delivery unless otherwise agreed in writing. Client acknowledges that the failure to return any image(s) to Licensor within the agreed upon time period(s) will cause economic damage to Licensor. Client agrees to pay the sum of $____ per week per image as and for a "holding fee". Such fee reflects licensor's costs and expenses attendant to its inability to license, offer for license, maintain its picture archive and or grant exclusivity to any prospective licensee with respect to any such images improperly retained. Client acknowledges that

such calculation is fair and reasonable and bears a rational relationship to the inconvenience, damages, lost income, costs and expenses incurred by Licensor as a result of such failure. In the event an image is not returned to Licensor within _____ days of delivery to Client, such images shall be deemed "lost" and Client shall pay to Licensor damages in accordance with paragraph "6" herein. Notwithstanding, Licensor may assert a claim for lost or unreturned images at any time subsequent to the agreed upon return date(s).

10. LOSS OR DAMAGE: IN CASE OF LOSS OR DAMAGE OF ANY ORIGINAL IMAGE(S), CLIENT AND LICENSOR AGREE THAT THE REASONABLE VALUE OF EACH ORIGINAL IMAGE IS AS SET FORTH ON THE FRONT PAGE OF THIS AGREEMENT. Once original Image(s) are lost or damaged the parties acknowledge it is extremely difficult, costly, impracticable and possibly impossible to fix their exact individual value in a court of law. Accordingly, Licensor and Client agree that the reasonable liquidated value of each original Image is in such amounts as are set forth on the front of this Agreement. Client agrees to pay Licensor such enumerated amount(s) for each lost or damaged original Image (irrespective of the total number of images lost or damaged) and Licensor agrees to limit Licensor's claim to that amount without regard to any claimed actual value of such Image. An Image shall be considered an original if no high reproduction quality duplicate of that Image exists. Client specifically agrees that the amount(s) set forth on the front of this Agreement is reasonable, reasonably related to the value of the image(s). Both parties have duly considered or have had ample opportunity to assess the number of images covered by this agreement as well as their content, subject matter, historical or newsworthy significance, reputation of the Licensor, cost of creation, any existing model and/or property releases, market cost of comparable images (if any) and other business considerations to be considered including but not limited to the ability or lack thereof too recreate any such lost image and whether the subject images can, in fact, be recreated.

The parties agree that the damage provisions agreed upon herein is not/are not punitive and that the establishment of such clause and amount is in the mutually beneficial economic interest of both the Client and Licensor in the event of loss or damage to any/all images. Client's agreement to these terms serves as a material inducement to licensor to deliver to Client the requested analog images.

*Court decisions in cases involving the valuation of lost, missing, or damaged analog film have been wildly inconsistent. So-called "standard provisions" assessing each and every image in a given delivery at $1,500 or $2,500 each have typically been struck down. Some decisions have incentivized stock agencies or clients in possession of analog imagery to have that imagery "go missing." We strongly advise that each image or group of images in a delivery be valued by the parties on the front of any delivery memo or invoice in such manner as to demonstrate to a court or jury that both parties thought about the value of the works, the subjects in the images, whether they can be re-shot, whether there are usable digital versions in existence, and agreed upon rational amounts per image if lost so as to avoid the cost and expense of lawyers and litigation. Varying amounts reflect that you have negotiated and mutually agreed with your client on these values. .*

*For example, the front of an invoice or delivery memo might read:*

| Subject | Shoot Date | Description/ Location | Image ID# | Replacement value |
|---|---|---|---|---|
| 1. Frank Sinatra | 11/22/56 | w/Ava Gardner @ the Copa, arguing | XYZ 243 | $3,000.00 |
| 2. Frank Sinatra | 11/22/56 | dressing room @ hotel, smoking | XYZ 255 | $1,875.00 |
| 3. Frank Sinatra | 11/22/56 | in car, face obscured | XYZ 259 | $865.00 |
| 4. Frank Sinatra | 11/22/63 | on telephone being told JFK is shot | XYZ 1454 | $8,500.00 |
| 5. Nancy Sinatra | 4/18/68 | Singing on Sullivan Show | XYZ 667 | $450.00 |
| 6. N. & T. Sinatra | 4/19/68 | Party at Patsy's | XYZ 668 | $175.00 |
| 7. "Famous Starlet" | 5/5/08 | Appears drunk w/ friends @ undisclosed club | XYZ 889 – XYZ 929 (40 images) | $50.00 each |

**Note:** *Subjects 1 through 6 are single images, while 7 reflects delivery of 40 images. The 40 images are clearly of a lesser value; including them helps to support to higher value placed on the more unique image.*

11. DELETION OF DIGITAL IMAGE(S): For all images supplied in digital format, Client agrees to delete all such images from its internal files, FTP servers/sites and backup or storage media within 90 days after their delivery date unless a longer retention period is agreed to in writing. In the event client loses, fails to timely locate, or renders a digital image unusable, Client agrees to pay Licensor all fees and expenses charged by Licensor to re-transmit or otherwise redeliver such image(s).

*Believe it or not, clients—especially newspapers—retain your images. They have been known to use them without creator's permission when there is a deadline, when the photographer is long dead, or in an attempt to make a free use of the image. This paragraph puts the infringer in a box. It means that they either illegally retained your image for unauthorized use, or appropriated it from someone else. It is a wonderfully effective clause for you to have in an infringement lawsuit.*

12. PAYMENT AND COLLECTION TERMS: Invoices from Licensor are payable upon receipt by Client. Client agrees to pay a late payment fee equal to 1.5% per month on any unpaid amount or balance. Such late fee(s) shall commence to run thirty (30) days after the issuance of this invoice. Such late fee(s) shall in no event exceed the lawful maximum permitted in the State of _____ with respect to commercial transactions of this type. In any action to enforce the terms of this Agreement, the prevailing party shall be entitled to recover their actual attorneys' fees, court costs and all other non-reimbursable litigation expenses such as expert witness fees and investigation expenses. The parties hereto consent to the jurisdiction of the courts of the State of _____, County of _____. The parties agree that any dispute arising out of this agreement shall be governed by the laws of the State of _____.

*In nearly all states, commercial parties can set interest rates on unpaid sums at rates higher than are permitted in consumer transactions. If such rate is not written into your agreement, you may be entitled to no more than the so-called "legal interest" rate, which in New York is now 9%. This clause more than doubles the interest due you by law on unpaid sums. Check with your local attorney to determine what maximum rate your state's law allows.*

*Insert your local state and county (preprinted on your forms) so that if there is to be litigation or even the threat of litigation, you can make the client come to you and spend the money connected with travel, hiring local counsel, and participating in a lawsuit thousands of miles from corporate headquarters. And oh yes, sometimes there is a home court advantage. Do you really want to have to search out a lawyer in some city or state far from home? Simply put, it's cheaper and more effective to fight on your home turf.*

13. TAX: Client shall pay and hold Licensor harmless on account of any sales, use, or other taxes or governmental charges of any kind, however denominated, imposed by any government, including any subsequent assessments, in connection with this Agreement, the Image(s), the Service(s) or any income earned or payments received by Licensor hereunder. To the extent that Licensor may be required to withhold or pay such taxes, Client shall promptly thereafter furnish Licensor with funds in the full amount of all the sums withheld or paid.

*Show this clause to your accountant. They'll thank us for it. In short, the client is taking responsibility for those things out of your control. Discuss with your accountant the appropriate procedure for you to use when and if your client claims any exemption from any taxes of any kind. You may for example be required to receive and retain certain tax forms from the client.*

14. RELEASES: No model, property, trademark, or other such release exists for any image(s) unless licensor submits to client a separate release signed by a third-party, model, or property owner.

*If releases are not part of the job, then there is no inference that they were provided by you or should have been provided by you. Copies of all releases used by you should be in the physical possession of you, your client, any ad agency, and any models. It's never a bad idea to have your client and model acknowledge receipt via e-mail or fax of any/all releases.*

15. ELECTRONIC RIGHTS: No electronic usage rights of any kind are licensed or granted hereunder unless as specifically set forth on the front of this Agreement. Licensor specifically reserves all rights not specifically conveyed to Client hereunder. Such rights reserved include but are not limited to all rights of publication, distribution, display or transmission in electronic and digital media of any kind, now existing and yet unknown. Usage rights for any kind of revision of a collective work including any later collective work in the same series, are expressly reserved by the Licensor.

*Again, only rights specifically licensed by you are granted. If the invoice does not enumerate the usage then no such usage has been conveyed.*

16. MODIFICATIONS, GOVERNING LAW AND MISCELLANEOUS: This Agreement sets forth the entire understanding and agreement between Licensor and Client regarding the Service(s) and/or the Image(s). This Agreement supersedes any and all prior representations and agreements regarding the Service(s) and/or the Image(s), whether written or verbal. Neither Licensor nor Client shall be bound by any purchase order, term, condition, representation, warranty or provision other than as specifically stated in this Agreement. No waiver or modification may be made to any term or condition contained in this Agreement unless in writing and signed by Licensor. Waiver of any one provision of this Agreement shall not be deemed to be a waiver of any other provision of this Agreement. Any objections to the terms of this Agreement must be made in writing and delivered to Licensor within ten days of the receipt of this Agreement by Client or Client's representative, or this Agreement shall not be binding. Notwithstanding anything to the contrary, no Image(s) may be used in any manner without Licensor's prior written consent, and Client's holding of any Image(s) constitutes Client's complete acceptance of this Agreement. The formation, interpretation, and performance of this Agreement shall be governed by the laws of the state of _____, excluding the conflict of laws rules of _____ (Same State). All paragraph captions in this Agreement are for reference only, and shall not be considered in construing this Agreement. This Agreement shall be construed in accordance with its terms and shall not be construed more favorably for or more strongly against Licensor or Client.

*Simply put, this clause makes your invoice the controlling legal document.*

17. COPYRIGHT/ENFORCEMENT OF EXCLUSIVE LICENSE: The sole right to pursue and/or defend any and all claims sounding in infringement of Licensor's copyright(s), trademark and/or intellectual property rights in the image(s), free from any claims by Client or any other person, whether or not the rights granted to Client are exclusive or non-exclusive shall be deemed retained by Licensor. If Licensor is determined not to possess such rights Client agrees to execute and deliver to Licensor such documents as Licensor reasonably requests to carry out the purpose of this clause so as to allow licensor the right to pursue and/or defend any and all claims sounding in infringement of its copyright(s), trademark and/or intellectual property rights in the image(s). Nothing contained herein shall be construed as limiting or waiving Client's right to enforce, defend or protect any copyright, trademark or intellectual property owned by it.

*This clause preserves your right to pursue any copyright claims even if you have granted your client exclusivity. A grant of exclusivity without language like the above could have the effect of giving your client the sole right to pursue an infringement of your copyright. That burden is frequently of no concern to your client, who may care only if the infringement directly affects sales of its product—with no regard for your reputation. A lack of this clause could effectively prevent you from starting a copyright infringement action.*

18. Client agrees whenever commercially reasonable to include the photo credit: ©
_____ or _____ PHOTOGRAPHY, INC. in conjunction with all uses of Licensor's image(s).

*Our experience is that photo credits are an extremely valuable marketing tool and assist greatly in the policing of copyrights. Some clients have no interest in giving you the credit or the free advertising. Clearly this is a negotiable clause.*

19. Client acknowledges that it has received and executed this two-sided Agreement and has been provided a copy of same.

*Many, many photographers fail to fax or email BOTH sides of their agreements to clients. In the event of a dispute, photographers re-print their then-current terms and conditions off their computer, which of course was never sent to the client nor part of the original transaction. **Keep paper copies with signatures of all transactions.** The fact that you back up your computer is irrelevant. This clause prevents your client from claiming that it never received the terms and conditions at the time of the transaction even though the terms on the back may be referenced on the front of the invoice.*

_____          _____          _____          _____          _____
Photographer/Licensor          Date          Client/Licensee          Title          Date

*Signature lines are there to be used! Names should be signed on the lines provided. As the licensor, make sure you sign the agreement prior to sending it on to the client.*

MODEL RELEASE

1.  I irrevocably and absolutely consent to the unrestricted use by _____ ("Photographer") and his/her/its successors, assigns, designees, and those acting with his/her/its permission and authority of any and all photographic or other images ("Images") of me that Photographer creates/created or makes/made on _____ for all purposes, in any form, and in any and all media now existing and yet unknown, including, without limitation, advertising, solicitation, stock photography, or trade, to copyright same in Photographer's own name or any other name that he/she/it may choose, and the right to use my name in connection therewith if Photographer so chooses.

2. I waive any right to inspect or approve the finished Images, advertising copy, accompanying text, or any other printed or visual matter that may be used in conjunction therewith, or to inspect or approve any version of any use(s) to which the Images may be applied or used in conjunction therewith.

3.  I release and discharge Photographer and those acting under his/her/its authority from any and all liabilities, claims, and demands arising out of or relating to any blurring, distortion, or alteration, whether intentional or otherwise, that may occur or be produced in connection with the Images, or in connection with any processing, alteration, transmission, display, or publication of the Images.

4. Model represents that he/she is not affiliated with any model agent or agency and has made no other agreement, whether written or oral, pertaining to the creation, use or publication of any of the Images.

5. Model acknowledges that he/she has read this release, understands the terms and conditions contained in it, and has been given a copy of it. Model further acknowledges that Photographer, as defined herein, relies on the accuracy of Model's representations.

6. My signature below acknowledges that I have received adequate consideration (if such be required) for the execution of this release.

Model's Name _____  Date _____

Model's Signature _____

Model's Address _____

Primary Phone Number _____  Secondary Phone Number _____

Witness' Signature _____

Witness' Address _____

## PROPERTY RELEASE

1. I irrevocably and absolutely consent to the unrestricted use by _____ ("Photographer") and his/her/its successors, assigns, designees, and those acting with his/her/its permission and authority of any and all photographic or other images ("Images") of the property that Photographer creates or makes, in whole or in part, individually or in conjunction with other photographs, for all purposes, in any form, in any and all media, including, without limitation, advertising, solicitation, stock photography, or trade.

2. I waive any right to inspect or approve the finished Images, advertising copy, accompanying text, or any other printed or visual matter that may be used in conjunction therewith, or to inspect or approve any version of any use(s) to which the Images may be applied or used in conjunction therewith.

3. I release and discharge Photographer and those acting under his/her/its authority from any and all liabilities, claims, and demands arising out of or relating to any blurring, distortion, or alteration, whether intentional or otherwise, that may occur or be produced in connection with the Images, or in connection with any processing, alteration, transmission, display, or publication of the Images.

4. I am the legal owner of the property or have the right to permit the making and use of the Images, as provided herein, and represent and warrant that this Agreement shall be binding on any and all successors-in-interest of the Property. I acknowledge that I have received a copy of this release.

5. This Agreement constitutes the sole, complete and exclusive agreement between Photographer and property owner regarding the Images and I am not relying on any other representation whether oral or written.

6. My signature below acknowledges that I have received adequate consideration (if such be required) for the execution of this release.

Property Owner's Name _____ Date _____

Property Owner's Signature _____

Property Owner's Address _____

Primary Phone Number _____ Secondary Phone Number _____

Witness' Signature _____

Witness' Address _____

MODEL RELEASE: MINOR

1. I irrevocably and absolutely consent to the unrestricted use by _____ ("Photographer") and his/her/its successors, assigns, and designees, and those acting with his/her/its permission and authority of any and all photographic or other images ("Images") of me that Photographer creates/created or makes/made on _____ for all purposes, in any form, and in any and all media, including, without limitation, advertising, solicitation, stock photography, or trade, or trade, to copyright same in Photographer's own name or any other name that he may choose, and the right to use my name in connection therewith if Photographer so chooses.

2. I waive any right to inspect or approve the finished Images, advertising copy, text, or other printed matter that may be used in conjunction therewith, or to inspect or approve the eventual use(s) to which the Images may be applied.

3. I release and discharge Photographer and those acting under its authority from any and all liabilities, claims and demands arising out of or relating to any blurring, distortion, or alteration whether intentional or otherwise, that may occur or be produced in connection with the Images, or in connection with any processing, alteration, transmission, display, or publication of the Images.

4. This Agreement constitutes the sole, complete and exclusive agreement between Photographer and Model regarding the Images and Model is not relying on any other representation whether oral or written. Model acknowledges that he/she has read this release and has received a copy of this release.

5. My signature below acknowledges that I have received adequate consideration (if such be required) for the execution of this release.

Model's Name _____ Date _____

Model's Signature _____

Model's Address _____

Model's Telephone Number_____

Model's Date of Birth_____ Model's Social Security Number_____

Witness' Signature _____

Witness' Address_____

If model is a minor, parent or guardian must sign below:

I, the undersigned, being parent or legal guardian of the minor whose name appears above, hereby consent to the foregoing conditions and warrant that I have the authority to give such consent.

Parent / Guardian's Name _____ Date _____
(circle appropriate designation)

Parent / Guardian's Signature _____

Parent / Guardian's Address _____

Parent / Guardian's Telephone Number _____

Parent / Guardian's Social Security Number _____

Witness' Signature _____

Witness' Address_____

CELEBRITY RELEASE

1. As a subject to be photographed by _____, I hereby give
_____ ("Photographer") and his/her/its successors, assigns, designees, and those acting
with his/her/its permission and authority the unconditional right to present any and all images from this shooting in
the photographer's personal portfolio or self-promotional materials, in exhibitions, in galleries and/or museums, and to
publish and republish my image and name worldwide in periodicals, books, and the following additional uses:

_____, _____, _____.

2. This release does not grant to Photographer legal rights to use images from this shooting for advertisement purposes
(unless set forth above) without signed written permission from me or my legal representative or my agent.

3. By signing below I acknowledge that: I have had sufficient time to consult with my manager or agent or legal representative regarding this release, understand and agree to its terms, and have received a signed copy of this release.

4. My signature below acknowledges that I have received adequate consideration (if such be required) for the execution
of this release.

Celebrity's Name _____        Date _____

Celebrity's Signature _____

Celebrity's Address _____

Witness' Signature _____

Witness' Address _____

# LIMITED MODEL RELEASE

1. I give _____ ("Photographer") and his/her/its successors, assigns, designees, and those acting with his/her/its authority permission to use the photographs he/she/it creates/created or makes/made on _____ for the sole purpose of fine art gallery shows and exhibits, photography books, and for use in Photographer's portfolio and self-promotion.

2. I waive any right to inspect or approve the finished images, or other printed matter that may be used in connection therewith.

3. Except as stated above, I do not give permission for the use of my name or said photographs for the purpose of advertising or endorsing any goods or services.

4. Model acknowledges that he/she has read this release, understands the terms and conditions contained in it, and has received a copy of it. Model further acknowledges that Photographer, as defined herein, relies on the accuracy of Model's representations.

5. My signature below acknowledges that I have received adequate consideration (if such be required) for the execution of this release.

Model's Name _____ Date _____

Model's Signature _____

Model's Address _____

Primary Phone Number _____ Secondary Phone Number _____

Witness' Signature _____

Witness' Address _____

## MODEL RELEASE AND CONSENT FORM: PHOTO RESIDUALS

1. For the consideration set forth below, the adequacy of which is hereby acknowledged, I irrevocably and absolutely consent to the unrestricted use by _____ ("Photographer") and his/her/its successors, assign, designees, and those acting with his/her/its permission and authority of any and all photographic or other images ("Images") of me that Photographer creates/created or makes/made on _____, for all purposes, in any form, and in any and all media now existing and yet unknown, including, without limitation, for promotional advertising, marketing or trade.

2. Photographer will pay me the below-specified percentage of any license fees if paid to and received by Photographer ("Residual Percentage") in connection with the commercial use of any Image(s), provided that I am recognizable in the end use of an Image. Any payments to me will be mailed within 90 days of the receipt of same to the address supplied by me and which appears below. If more than one recognizable person appears in connection with the use of any Image, the Photographer's payment to me shall be apportioned on a pro-rata basis between such recognizable persons. Notwithstanding anything herein to the contrary, Photographer may use any of the Images in any manner in connection with Photographer's personal promotion and/or advertising without any kind of payment to me.

3. I release and discharge Photographer and Photographer's designees from any liabilities, claims, and demands arising under any state or federal law or statute out of or relating to any Image(s), including but not limited to any alteration that may occur or be produced, and any text, images and/or graphics that may appear in association with the Images.

4. This Agreement constitutes the sole and complete agreement between Photographer and model, superseding any prior agreement(s) (if any), whether written or oral, regarding the Images, and I am not relying on any other representation, whether oral or written. I acknowledge that I have received a copy of this Release and Consent form and agree to retain such copy.

5. I acknowledge that a copy of this Consent and Release has been furnished to Model Agency. If payments are made to Agency, I agree that it is Agency's sole responsibility to pay me, and Photographer is released from responsibility of payment.

6. My signature below acknowledges that I have received adequate consideration (if such be required) for the execution of this release.

Description of consideration: _____

Residual Percentage: _____ %   Other: _____

Make Payments to:  (a) Model  (b) Agent_____

Model's Name _____     Date _____

Model's Signature _____

Model's Address _____

Model's Telephone Number _____

Model's Secondary Phone Number_____

Model's Social Security or Driver's License Number_____

Photographer's Name_____     Date _____

Photographer's Signature _____

Witness' Signature _____

Witness' Address _____

# INDEX

## A

agents  30, 99, 100

arbitration  40

audience test  18,
(*see also* derivatives, right of)

## B

bankruptcy  97, 98

Berne Convention  35, 84

blacklist  44

bundle of rights  18-19, 22

## C

celebrities  41, 86, 102, 123

chat rooms  (*see* social networks)

bidding, comparative
and competitive  103-105

compensatory damages  40

copyright

  definition of  16

  history of  29, 31, 51, 84, 93

  notice  21, 26, 53, 84, 113

## D

derivatives, right of  18, 20-21, 24, 26, 27,

display, right of  19

distribution, right of  18, 19, 111, 113, 118

## E

editorial use  80, 82, 86-87

## F

fair use  34, 50

factoids  76-77 (*see also* myths)

## G

Gutenberg  31

## I

infringement  18, 19, 23, 24, 26, 27, 30, 32-35, 39, 40, 46, 47, 49, 52-53, 55, 64, 69, 97, 98, 100, 114, 116, 119

injunction  34, 35, 41

intellectual property  12, 17, 25, 53, 82, 100, 102, 119

invoices  41, 90-119

## L

lawsuits  21, 22, 30, 35, 39, 40, 44, 46, 78, 80, 81, 82, 85, 87, 100, 112, 116, 117

lawyer fees  41

licensing  17, 18, 19, 22, 30, 35, 40, 43, 47, 50, 52, 82, 91, 95, 96-97, 98, 101-102

Lisa Steinberg  42-43